IMAGES
of America

MIAMI BEACH

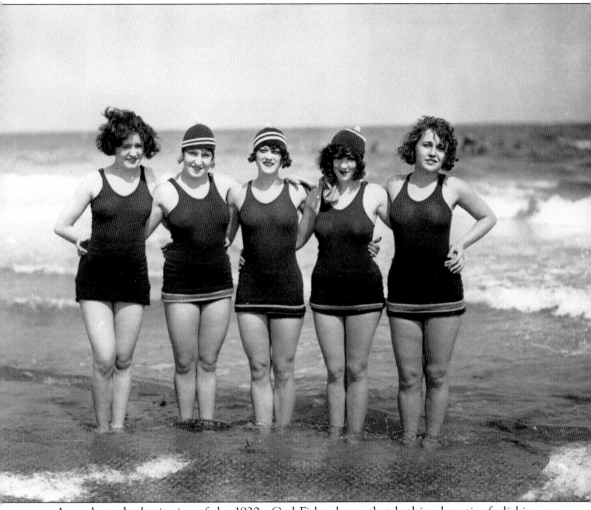

As early as the beginning of the 1920s, Carl Fisher knew that bathing beauties frolicking on the sands of Miami Beach would sell land, and famed Miami lensman Gleason Waite Romer photographed this bevy of pulchritudinous cuties standing ankle deep in the Miami Beach surf in January 1925.

IMAGES
of America

MIAMI BEACH

Seth Bramson

ARCADIA
PUBLISHING

Published by Arcadia Publishing
Charleston, South Carolina

Printed in the United States of America

Library of Congress Catalog Card Number: 2005926988

For all general information contact Arcadia Publishing at:
Telephone 843-853-2070
Fax 843-853-0044
E-mail sales@arcadiapublishing.com
For customer service and orders:
Toll-Free 1-888-313-2665

Visit us on the Internet at www.arcadiapublishing.com

To my brother, Bennett; my beautiful bride, Myrna; our daughter, Saralyn Nemser, and Myrna's son, Benjamin Nemser; my grandsons, Joshua Nemser and Harrison Seaman; my niece Dara Bramson; and my friends Steve Cypen and Dave Rogers, all of whom, when I needed their help, came through like the champs they truly are, this book is, with great feeling, love, and fondness, dedicated.

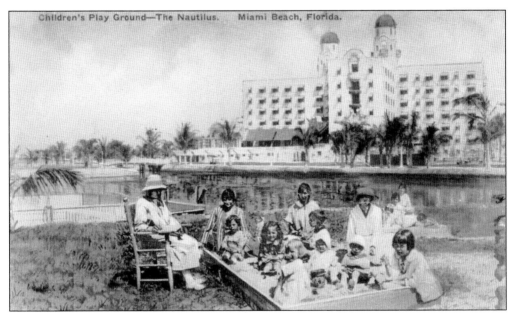

From the time it was built in the early 1920s until World War II, the Nautilus Hotel was a favorite of the moneyed set, offering everything from access to the polo fields to some of Miami Beach's first children's programs. The hotel's staff of nurses and kiddie counselors made sure the children were well cared for.

CONTENTS

ACKNOWLEDGMENTS

The difference between this book and every other book ever done on the history of Miami or Miami Beach is that this book has used, almost entirely and with only a very few exceptions, photographs from private collections, and I think and believe it has been greatly enriched by using "family" photographs and views, most never before seen outside the confines of the owners' homes and certainly never before published.

With great gratitude, I thank the following: Judge Irving and Hazel Cypen, for allowing me access to their hundreds and hundreds of photographs; Joyce Grossman, who shared the photograph of her family's drug store on Miami Beach with me; Joy Van Wye Malakoff, who let me go through box after box of family photographs beginning with the family's arrival in 1924; Bookie and David Rogers, for their graciousness in providing several images; Mitchell Rosen, who allowed me to use two very rare scenes from his collection; David Schoenfeld, who said, "I can't do enough to help"; Gail and Mario Talucci, who never hesitated to let me go through "the stuff"; Gregg Turner, my Plant System book coauthor, whose insights, wisdom, patience, and support never failed me; Joan Kandel Worton, who loaned several fine Miami Beach images; my friends and classmates from our great class of 1962 at Miami Beach High School, the members of the Greater North Miami Historical Society, and the Miami Memorabilia Collectors Club; and so very many others who warmly encouraged me throughout. To one and all, thank you.

(Unless specifically credited otherwise, all photographs herein are from the author's collection.)

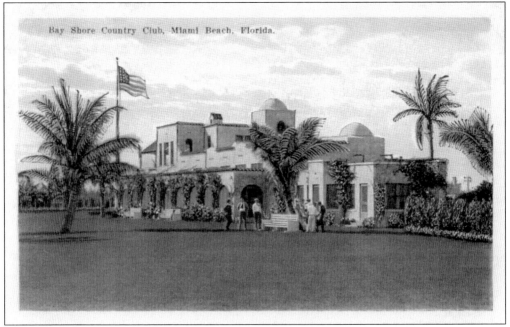

Among the promotional tools that Fisher publicist Steve Hanagan would use was golf, which, in Miami Beach's tropical climate, could be played in shirt sleeves year-round. Bay Shore Country Club was the beach's premiere course and is still a favorite of the duffers today.

INTRODUCTION

It must be a true story, for nobody ever could come up with a fairy tale or fable to match the incredible real-life saga of the building, growth, fame, decline, and rebirth of one of the world's greatest resorts, known for many years as "the world's playground." Also the epicenter of the art deco movement, Miami Beach has preserved an entire district of buildings in that unique architectural style.

The story began to unfold in 1870 when Henry B. Lum and his 15-year-old son, Charles, after coming to Florida for the first time in 1868, made their way by sailboat from Key West to what would become Miami Beach. Finding three coconut trees growing on the weed-, mosquito-, rat-, and rabbit-infested island, they came up with the idea of developing a coconut plantation. Although they would not return for 12 years, they bought a good deal of land from the government for 35¢ an acre and were able to talk fellow New Jerseyites Ezra Osborn and Elnathan T. Field into investing with them. Eventually paying between 75¢ and $1.25 an acre, they would own most of a 100-mile strip of land along the east coast from Cape Florida to just north of Jupiter, and they planted somewhere in the vicinity of 155,000 coconuts along the beach. Lum and his son soon sold out to Osborn and Field, leaving them with control of the oceanfront acreage.

On a trip back to New Jersey, Field would run across his old friend John S. Collins, who invested $5,000 with him and who would eventually buy Osborn out, so that Field and Collins were partners in the venture. Collins then interested his son-in-law, Thomas J. Pancoast, in the project, and Pancoast, in turn, would make a considerable investment with his father-in-law.

Collins, realizing that a bridge to connect the then-named Ocean Beach to the mainland was a necessity, began building what would be, upon its completion, the longest wooden bridge in the world. But about halfway across, Collins ran out of money.

Through a series of extraordinary coincidences, Collins would make the acquaintance of one Carl Graham Fisher, who is generally considered to be the founder and builder of Miami Beach.

Fisher, the builder of the Indianapolis Motor Speedway, inventor and owner of Prest-o-Lite Corporation, and developer of the Lincoln Highway, had accumulated, even in modern dollars, a fortune, and he would eventually spend most of that fortune building Miami Beach.

Although traveling extensively and involved with other priorities initially, Fisher placed his friend John H. Levi in charge of operations on the beach, and they would both be present at the opening of the Collins Bridge on June 12, 1913.

There would soon be several companies selling Miami Beach land, and they would all be consolidated into the Miami Beach Improvement Company. Eventually, the first hotel, Brown's, would be built at what became First Street and Ocean Drive, and four great bathing casinos would, for many years, be part of the landscape. Each of them—Smith's, Hardie's, Cook's, and the St. John's (later Fisher's, the Roman Pools, and the Everglades Club)—would have their partisans.

A canal was dug from immediately south of the Collins Bridge (later the Venetian Causeway) on a diagonal across the island, and a lake was dug out with its south end being just north of what is now 23rd Street. To memorialize Collins, Fisher named the canal after him, and the great oceanfront drive that would stretch from the south end of Miami Beach to the north end of Sunny Isles would also bear the Collins name. Fisher named the body of water after Pancoast, who built his home at the north end of the lake.

As Fisher poured millions of dollars into "the beach," others became both interested in and part of the development. "Doc" Dammers, who would gain his fame as the salesman supreme for George Merrick in Coral Gables, began with Fisher. While Levi was responsible for much of the work, and Fisher spent every possible moment supervising, Charles W. ("Pete") Chase Sr. would take over for Dammers and become the head of Fisher's sales organization and the founder of the Miami Beach Chamber of Commerce.

J. N. Lummus would become the first mayor of Miami Beach. The island was incorporated as a town in 1915 and as a city on May 1, 1917. Lummus and his brother would eventually have a beautiful oceanfront park named for them, and it would be J. N. who would help persuade the county commission to support a second causeway that would connect Miami and the beach. The County (later MacArthur) Causeway opened February 17, 1920.

The great story unfolds from there. Fisher and Chase, through New York connections, had heard about a publicist with "the magic touch." "Whatever he takes on," they were told, "becomes a success," and so it was that the great publicist Steve Hanagan, the "inventor" of the pretty girls in bathing suits (known as "cheesecake") frolicking on Miami Beach in mid-winter gambit, would spread the news far and wide that Miami Beach was the world's greatest resort.

Following World War II, a building boom of previously unimagined proportions took hold, and Collins Avenue, from one end to the other with scant and very short breaks for public beaches, would be lined with hotels and, later, apartment houses. The magnificent Collins Avenue mansions would be toppled, and in their places, hotels such as the Saxony, Fontainebleau, Eden Roc, Doral, and many more would rise.

The late 1960s would see the downturn and the 1970s were a depressing time for the once heralded resort, but in the very late 1970s and early 1980s, Barbara Capitman and her son, Andrew, would see the beauty and importance of the art deco style. Through their efforts, almost all of what is now called "SoBe," South Beach, would become the nation's first art deco historic district.

To add to the rebirth, the Jewish Museum of Florida, under the direction of Marcia Zerevitz, was founded, and a long-term lease in Miami Beach's first synagogue, Temple Beth Jacob at Third and Washington, was arranged.

South Beach and the deco district would be further enhanced by the great Mitchell (Mickey) Wolfson Jr., son of the founder of Wometco Enterprises, who would buy the Washington Storage building and create a nationally renowned museum, the Museum of the Decorative and Propaganda Arts, which is now associated with Florida International University.

The story, of course, is far from over, and whatever and however the twists and turns occur, Miami Beach will somehow manage to remain in the national consciousness as it reinvents itself periodically. It continues to be a place to see, be seen, grow up, live, dine, stay, frolic, and perhaps most of all enjoy both the history and the now, for, as it says on the monument to Carl Fisher at Fifty-First Street and Alton Road, "He Carved a Great City from a Jungle."

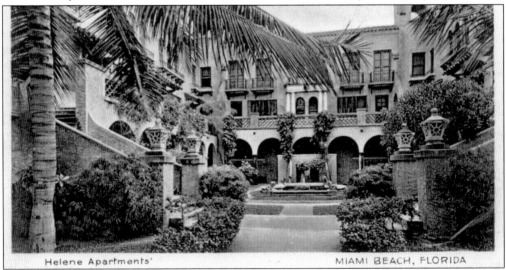

Helene Apartments' MIAMI BEACH, FLORIDA

The Helene Apartments were at 1040 Fifteenth Street, just a few blocks east of Alton Road, and the setting was everything tropical that the winter visitor could ask for. Sadly long gone, the courtyard was reminiscent of the Alcazar Hotel in St. Augustine.

One

IN THE BEGINNING

It was certainly not an auspicious start for what would eventually become the world's most desirable vacation resort, for the spit of sand at the southeast corner of the Florida coast was inhospitable, devoid of anything even resembling lodgings and, except by water, completely inaccessible.

It was the idea of farming that began the development of the island. The initial planting of choice was the coconut, but when Ezra Osborn and Elnathan T. Field realized that they could not and would not become rich by farming, they elected to sell their acreage to others. Those others had different plans.

Henry Morrison Flagler, of Standard Oil, built much, if not most, of the east coast of Florida, and Flagler is credited with founding both Palm Beach and Miami. It was his foresight, faith, and belief in the future of the Florida east coast that would inspire all who followed.

Although a magnificent monument to him and his great and immortal works was built in his honor on an island in Biscayne Bay, Flagler never ventured across that bay. When he died in 1913, Miami Beach was two years away from incorporation. The building and development of what was to become the most desirable resort destination in America was left to a hardy group of men from diverse backgrounds and businesses, all of whom had total faith in their ability to complete the incredible work that they were about to start.

The names of those pioneers, from Lum, Field, and Osborn to Pancoast, Levi, Chase, Dammers, and the Lummus brothers, must be enshrined in history, but one name, above all, was responsible for all that would follow, and that person, that name, was Carl Graham Fisher.

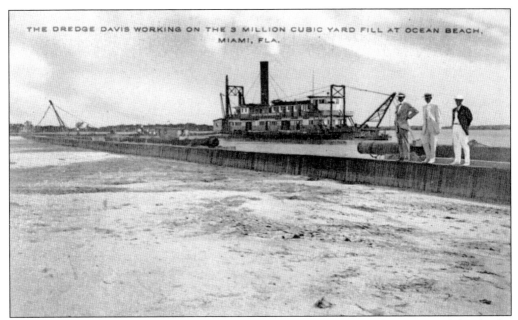

The Ocean Beach Realty Company was one of Fisher's early development and land sales subsidiaries. To sell Alton Beach/Ocean Beach/Miami Beach, the ocean and bay had to be dredged and the sea and bay literally filled in. Here the dredge *Davis* is pumping in some of the three million cubic yards of fill that would eventually form a tropical paradise.

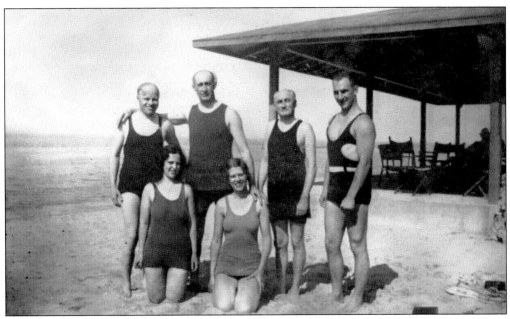

From an old family album, this adventuresome group is enjoying Ocean Beach to its fullest, likely on the sand behind Smith's Casino at what is now First Street and Ocean Drive but was then simply "The Casino." Reached only by ferry from Miami and then a healthy hike over a dirt trail from the bay side to the ocean, Ocean Beach had cooling sea breezes and pleasant Atlantic waters that would make the trek worthwhile.

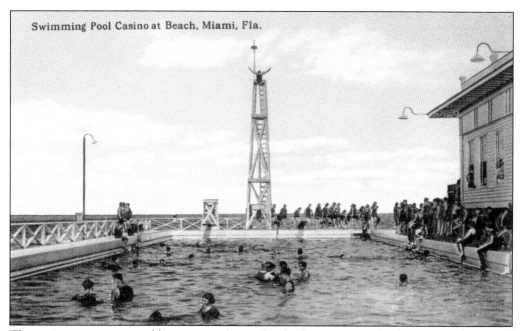

Swimming Pool Casino at Beach, Miami, Fla.

The casinos were not gambling casinos but rather bathing casinos. In this very early view of Smith's, we see the high diving board on which only the most daring (and the young swains attempting to impress their young women) would dive from the top.

John H. Levi, who would later be mayor of Miami Beach, became Fisher's confidante and "ramrod" as Miami Beach was being built. Levi, who had been a yacht salesman, met Fisher during a boating excursion and told him about the "island in the sun."

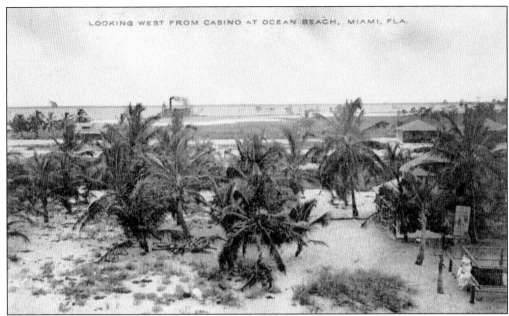

As the island was filled, the coconut trees left over from the original plantings began to grow and became a symbol of both Miami and the beach. In this Ocean Beach Realty Company view from the south end of the beach looking west from the casino, the dredge (likely the *Davis*) is still hard at work pumping sand from the bay.

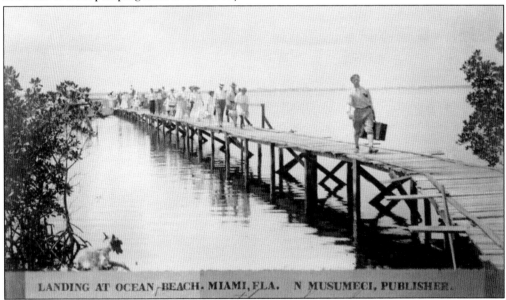

LANDING AT OCEAN BEACH. MIAMI, FLA. N. MUSUMECI, PUBLISHER.

Prior to the opening of the Collins Bridge in 1913, those wishing to enjoy a day in East Miami (as it was known for a short time) or at "the beach" would embark from Elser's Pier at the foot of Twelfth Street (now Flagler Street) in Miami and enjoy crossing Biscayne Bay aboard the *Mauritania* or the *Lusitania*, as the ferries was so grandiosely named. Beachgoers arrived at this long pier at the foot of what is now Biscayne Street, Miami Beach's southernmost street. They would then walk across the trail to the beach where they could eventually take their pick of Smith's, Hardie's, or Cook's Casinos.

An incredibly rare 1906 view shows the wilds of the barrier islands across from the mainland. There was no road yet, and visitors, although few and far between, had to cope with mosquitoes, rodents, and other unpleasant vermin, not to mention the inhospitable flora of the time.

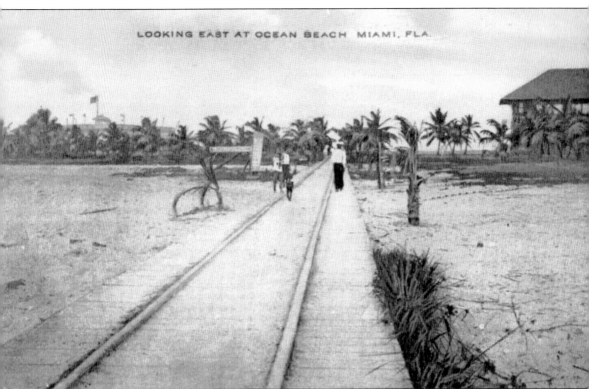

LOOKING EAST AT OCEAN BEACH MIAMI, FLA.

Carl Fisher, one of America's greatest 20th-century entrepreneurs and land developers, not only built Miami Beach but also built a short tram railway along the ocean front. Though the line was short lived, he sent passes to the presidents of major railroads, giving them free travel on the Alton Beach Railroad Company. Many of them reciprocated so that Fisher had passes on no small number of the major railroads for his "car [meaning his railroad car, although we do not believe he ever owned his own private car] and party" good over that railroad for the ensuing year.

A stand of young coconut trees, either at sunrise or sunset, helped to enhance the image of the place where summer spent the winter. Though no location is given on the back of the photograph, it appears to be somewhere along Indian Creek, likely just north of what is today Twenty-seventh Street.

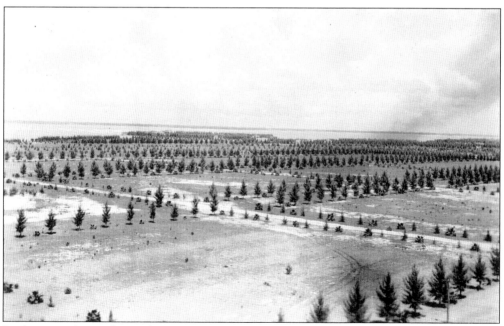

Looking northwest from what is approximately today's Fourteenth or Fifteenth Street, the plantings that helped to solidify the pumped-in soil can be seen. The only island visible in center background is Bull Island (later Belle Isle). The Collins Bridge had not been built, and there is nary an island extant to mar the pristine beauty of Biscayne Bay.

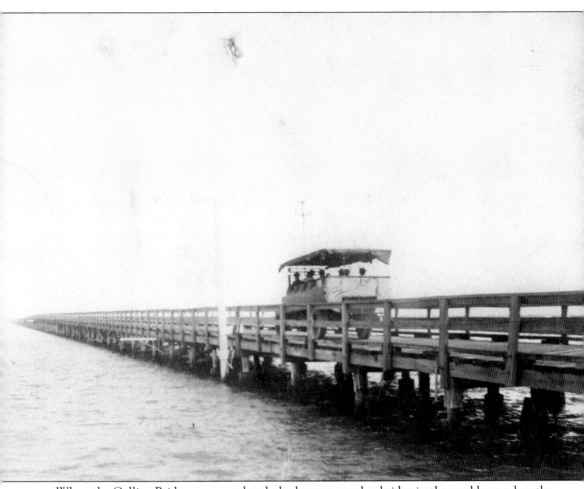

When the Collins Bridge was completed, the longest wooden bridge in the world was a lengthy and lonely ride across the bay. As can be noted in this incredible view, it was in the early days a solitary trip.

A Miami Beach pioneer and associate of Fisher, Thomas J. Pancoast believed so strongly in the future of the island that he built his home at the north end of the lake that would bear his name. Sadly that beautiful edifice was later replaced with hotels.

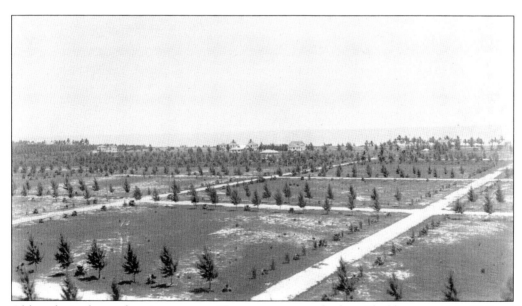

Although similar to the view on page 15, we are now on the bay side (the west side) of Miami Beach and looking east toward the Atlantic Ocean. A number of residences have sprung up.

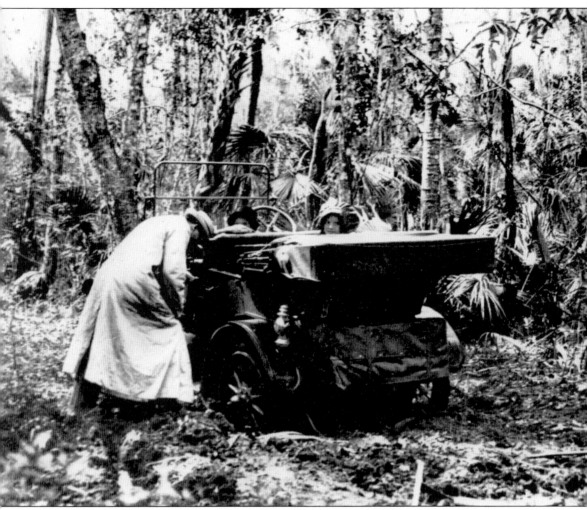

When the Collins Bridge opened in 1913, the roads were barely paved, if at all. Woe be unto him who should set off onto a trail in the rainy season taking his or her chances with the muck, mire, and weather. No few unhappy motorists learned the hard way that the island off the coast was no place for the faint of heart or weak of back.

Brown's was the first hotel on Miami Beach, but it would not be long before other plucky hoteliers were willing to take a chance, take the proverbial plunge, and open an inn on the beach. Soon after Brown's was completed, the Lido, at what would become 336 Collins Avenue, was opened. Although the event occurred several years into Miami Beach's development, it is discernible that this folder is of 1920s issue, as there is no telephone number anywhere on the promotional. Rates were $5 a week per person with two in a room including breakfast. Plus the hotel was "air cooled," meaning of course that windows were opened to enjoy the soothing ocean breeze.

Hotel LIDO

AIR COOLED

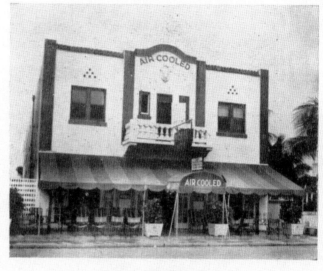

Open All The Year

$5.00 a Week per Person
Two in a room
INCLUDING YOUR CHOICE
OF CLUB BREAKFAST

●

336 COLLINS AVENUE

MIAMI BEACH FLORIDA

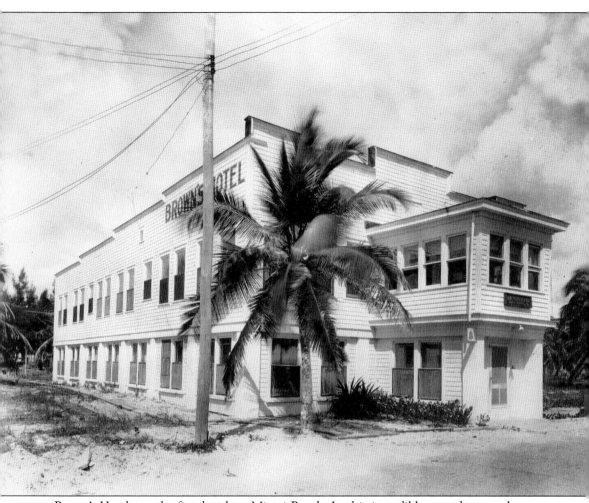

Brown's Hotel was the first hotel on Miami Beach. In this incredibly rare photograph, we see the then-new hotel in all its glory. Through the years, the building somehow survived being plastered on the outside and taking on new names, but it continues to exist and outlast many newer edifices. Today Brown's is undergoing a complete face and body lift and will see new life as a condominium with a great heritage and a past that is almost as old as the city itself.

Two

THE 1920S AND THE BEGINNING OF FAME

With the land "bulkheaded" and solidified, growth began in earnest. Fisher supported the idea of the second causeway, and shortly after its opening in 1920, the Miami Beach Electric Railway (later the Miami Beach Railway Company) would begin streetcar service from Miami, across the County Causeway, and eventually north on Miami Beach. One route went up Washington Avenue and Pinetree Drive all the way to Fifty-first Street. The other went up Alton Road to the polo fields at Forty-fourth Street and a short distance beyond. A loop served South Beach, and with the two causeways and the trolley line in operation, the rush to the beach accelerated.

Fisher was pouring millions into Miami Beach, and he had made his first fortune by publicizing what he was doing. Taking what he learned from his past endeavors, he hired Steve Hanagan, the man who invented "cheesecake" (bathing beauties posing in the surf in the dead of winter) as his publicity chief. Hanagan earned his pay. Beginning with column notes in the newspapers of New York, Chicago, Philadelphia, Boston, and other great Eastern and Midwestern cities, Hanagan would eventually feed them hundreds upon hundreds of photographs of beautiful young women in brief (for the day) bathing attire lounging on the beach, leaning on coconut palm trees, smiling at handsome young men, and even engaging in acrobatics on the beach.

In 1925, the decision was made to hire a full-time manager for the rapidly growing city. A young man from Nebraska, Claude Renshaw, was selected for the position. He would remain as city manager until his retirement in 1958, overseeing the growth of the city and becoming part of its history.

These were heady times, and Fisher, beginning to see some return on his enormous investment, would not only dedicate land for parks and golf courses but would build the magnificent monument to "the founder," Henry M. Flagler, in Biscayne Bay between the two causeways. Today the name Carl Graham Fisher is synonymous with Miami Beach. Indeed, it was he who brought the great resort to fruition.

When the Pancoast Hotel was built by Thomas Pancoast, it was well north of "the center of town," at 25th Street and the ocean. It was a beautiful and elegant building, with a circular driveway and a striking interior. It was, of course, a favorite of the Pancoast family as well as Jane and Carl Fisher.

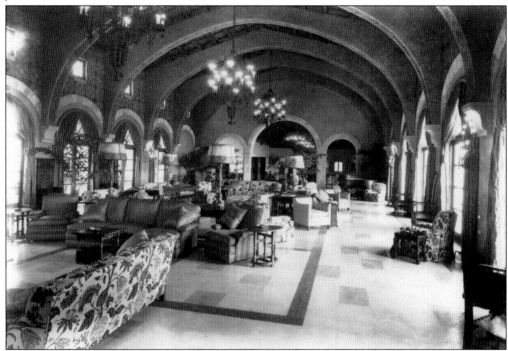

The Pancoast was light and airy and elegant, built to take advantage of the ocean breezes. Open in the winter season only, the hotel did not need air conditioning—not yet in use in hotels anyway. This view shows the lobby of the hotel, and the arches, shown in the exterior photo above, are evident in this interior view.

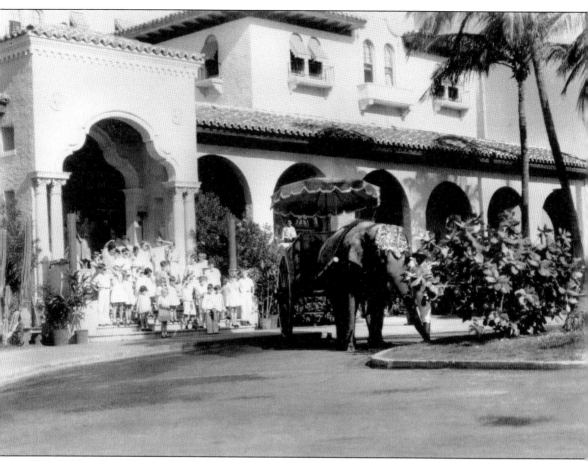

The children loved Rosie the elephant, who was gentle and relaxed. Her mahout (handler) is to the left of her trunk and is partially hidden by the bush on the right. The children, all dressed in white, were anxiously awaiting their turn to ride on Rosie, and she loved them and their attention, not to mention the frequent snacks.

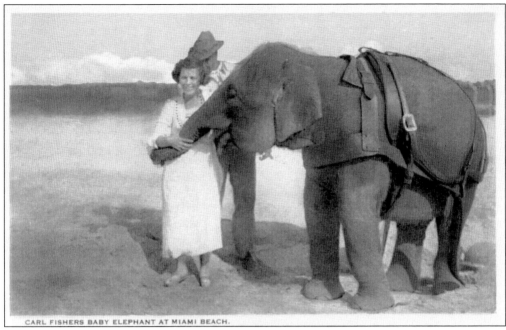

CARL FISHERS BABY ELEPHANT AT MIAMI BEACH.

Fisher brought Rosie to Miami Beach while sand was still being pumped in from the ocean and the bay. A young Rosie is entwining the lady with her trunk. By the look of the hat and the cigar in his left hand, one could lean toward identifying the partially hidden man in the picture as Carl Fisher. The woman may be his wife. Jane. (Courtesy collection of Mitchell Rosen.)

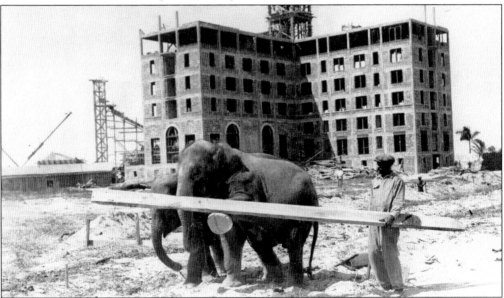

Although there are several well-known views of Rosie working at what is now Arthur Godfrey Road (Forty-first Street) and Alton Road, this image is one of the rarest and has never before been published. Rosie is lifting a heavy timber with her left front leg, while her soon-to-exit-the-scene partner is behind her. Not only are there very few pictures of the two elephants together in action, but the view of the Nautilus Hotel under construction in the background is one that has never been published before.

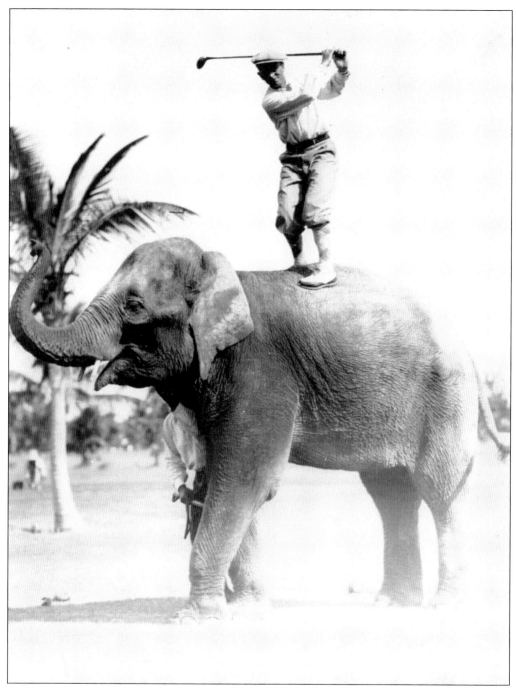

Rosie loved people, and Hanagan once told Fisher that she loved being photographed even more. Here Miami Beach Bayshore Golf Club professional John Brophy spanks out a long drive from atop Rosie's back. She knew that her patience would be rewarded, and after every photograph session, she would receive various snacks and treats.

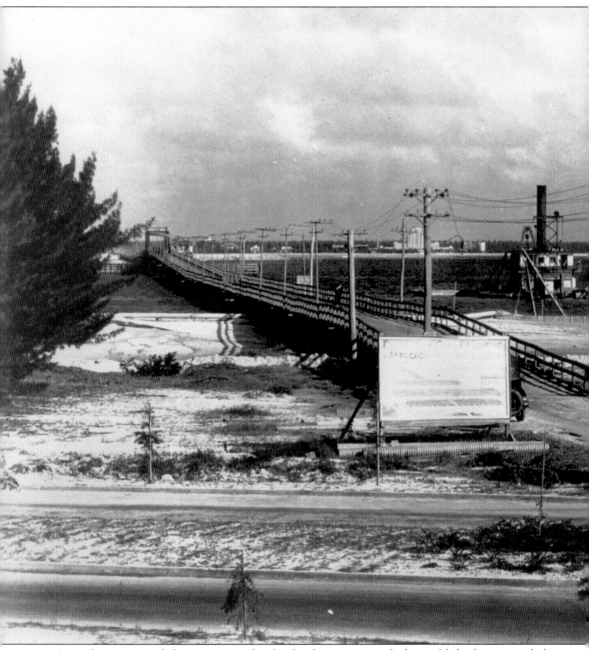

As with so many of the images in this book, this is a never-before-published view, and the least applicable adjective for any Miami/Miami Beach/South Florida historian would have to be "extraordinary." This view was taken from Bayshore Drive, two short blocks east of the Boulevard and looking east toward Miami Beach on January 9, 1925. After 12 years of service, the old Collins Bridge was on its last legs. The County Causeway, to the right, which was free to automobiles, had siphoned off much of the old bridge's toll-paying traffic. The Collins Bridge was sold to the Venetian Islands Company, which proceeded to build the beautiful Venetian Causeway and fill in the bay bottom with romantically named islands, including San Marino, DiLido, Rivo Alto, Biscayne, and San Marco. To be certain that the entire project would carry

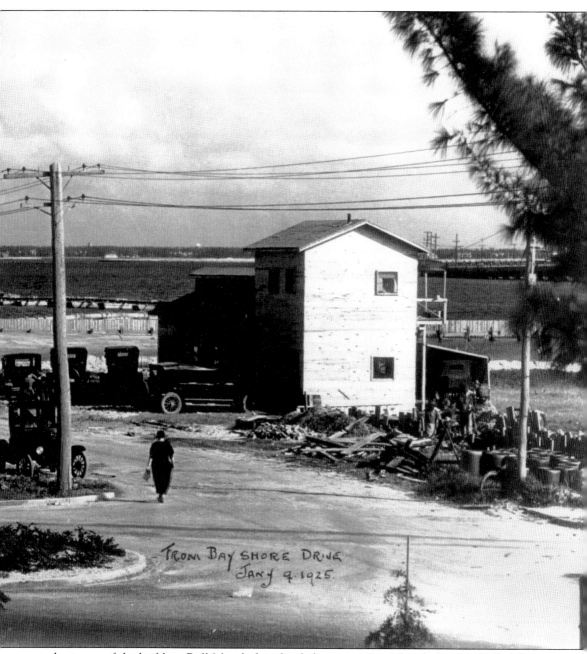

FROM BAY SHORE DRIVE
Jany 9. 1925.

out the image of the builders, Bull Island, the island closest to Miami Beach, became Belle Isle. While Rivo Alto, DiLido, and San Marino remain islands of beautiful homes, Belle Isle has been marred with high-rise apartments and condominiums oversized in relation to the island and the causeway. The sign on the right is the much photographed (and crooked) toll sign. The sign on the left shows the islands to be built; the Flamingo Hotel, with its distinctive dome, on the beach side; and the Flagler monument, built by Mr. Fisher, visible in the center of the photograph. The land between the two causeways is now occupied by the *Miami Herald*, and to the left of today's Venetian causeway entrance on NE Fifteenth Street are apartment houses and hotels.

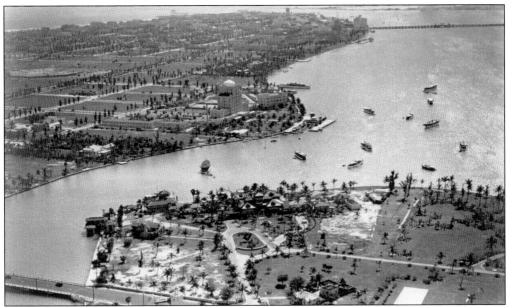

This picture was taken from a Goodyear blimp or a biplane just above the northern side of Belle Isle, looking southeast toward Miami Beach. The magnificent homes are, unhappily, long gone, replaced by huge and out-of-proportion to their surroundings high-rise apartments. The Flamingo Hotel is directly southeast of the island, while the Floridian is farther south, on West Avenue just north of the entrance to the County Causeway. Due east of the Flamingo are the open fields of what would become Flamingo Park, and at the very far southeast corner of Miami Beach, the pier at the foot of Biscayne Street can be seen.

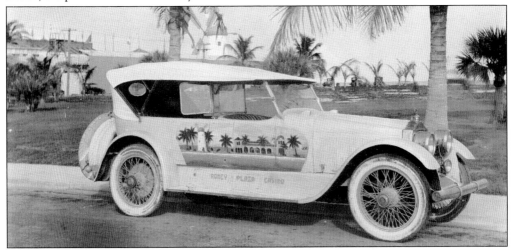

The Roman Pools, the last constructed of the Miami Beach's bathing casinos, was also the most elaborate with shops, restaurants, private cabanas, and somewhat frequent name changes. It was known through the years as the Fisher Casino, the St. Johns Casino, the Roman Pools, and, in its last incarnation, the Everglades Club. Numerous beachgoers enjoyed the pools, the beach, and the luxury of living on the island and being able to play tourist every weekend. The trademark windmill in the background can be seen, and the "company car" carries the legend Roney Plaza Casino, which leads us to believe that, for a short time, the hotel managed or operated this facility.

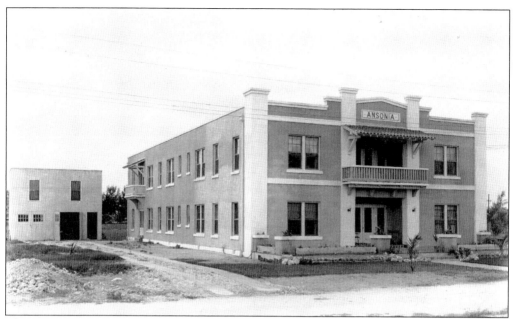

The Ansonia (complete with garage) was the first apartment building built north of Fifth Street. It was, for a good few years, the rental of choice for those who either were staying in Miami Beach for the winter or who preferred apartment living to home ownership.

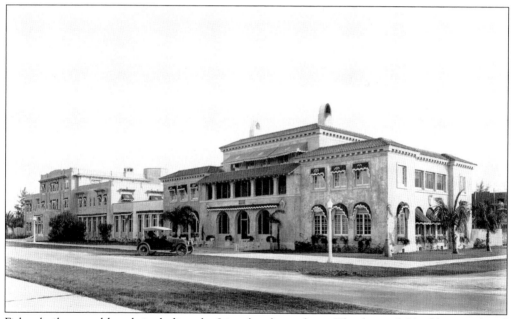

Fisher built several hotels including the Lincoln, shown here. This beautiful building, replaced by Mercantile National Bank and an office building, proffered fine accommodations and elegantly served gourmet food. This view looks southeast from the northwest corner of Drexel Avenue and Lincoln Road. The east end of the hotel is at the corner of Lincoln and Washington Avenue. This 1920 or 1921 view would indicate that the lone horseless carriage parked in front was manufactured in one of those years.

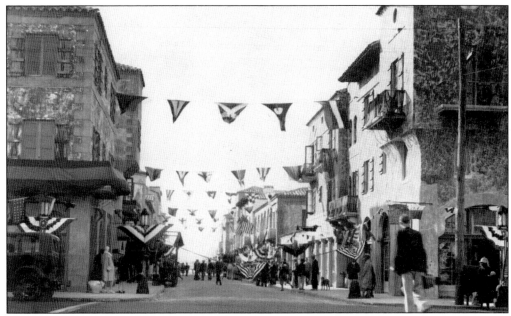

To trumpet Miami Beach's complete return from the disastrous September 1926 hurricane, Espanola Way, the Spanish Village, opened for business with great fanfare on January 8, 1927. Looking west from Washington Avenue, the building on the left is the Clay Hotel, now a well-known youth hostel that was notorious many years before for having a sign painted on the building facing Washington Avenue that read "No Jews." Although restricted clientele operations were rampant on the beach, this was one of the few blatant outside signs that specifically stated that those of Hebrew origins were unwelcome.

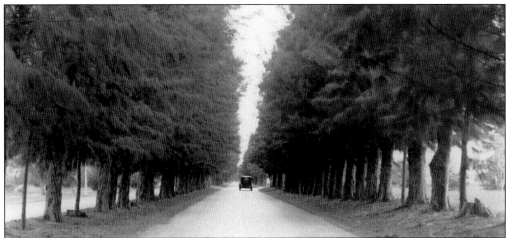

Among the great names that would come to be associated with Miami Beach were Harvey Firestone, of tire fame, and John Oliver LaGorce, of *National Geographic* magazine fame. Nobody is quite sure whether it was one of them, Pancoast, or somebody else who came up with the idea of planting pine trees to flank a bridle path, but plant them they did, and the bridle path would eventually be paved for automobile usage, with a row of pine trees in the median of what is now the beautiful Pine Tree Drive. Homes line on either side from Twenty-seventh Street all the way north to where the street ends today at the entrance to LaGorce Island, two blocks north of Sixty-third Street.

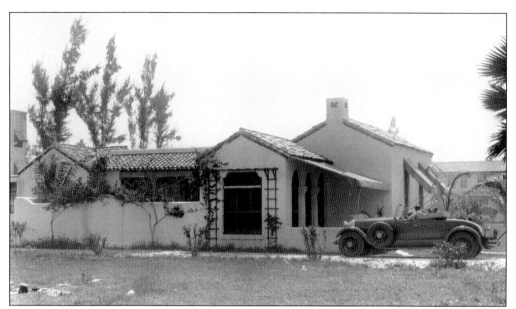

The Van Wye family moved to Miami Beach c. 1924. Mr. Van Wye built this lovely home at 970 Lenox Avenue, eight blocks below Lincoln Road. In 1940, they moved farther north on Miami Beach. Their daughter, Joy, a graduate of Miami Beach High School and a longtime banker, remains a beach resident. (Courtesy Joy Van Wye Malakoff.)

To provide milk and other dairy products for both his employees and the beach's residents, Fisher built the Miami Beach dairy just north of what is now Forty-first Street, on Chase Avenue. Long gone, the farm provided a variety of wholesome products for the people of the beach.

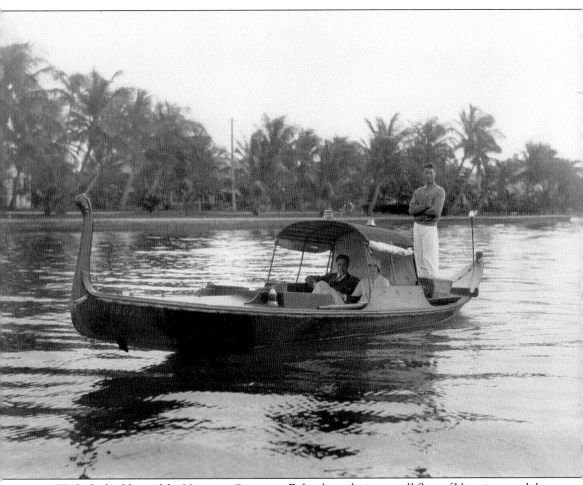

With the building of the Venetian Causeway, Fisher brought in a small fleet of Venetian gondolas, complete with Italian gondoliers. For close to 15 years, they operated in part of the Collins Canal and on Biscayne Bay. While it is unclear today exactly when the last boat operated, the gondolas remain part and parcel of the lore of Miami Beach.

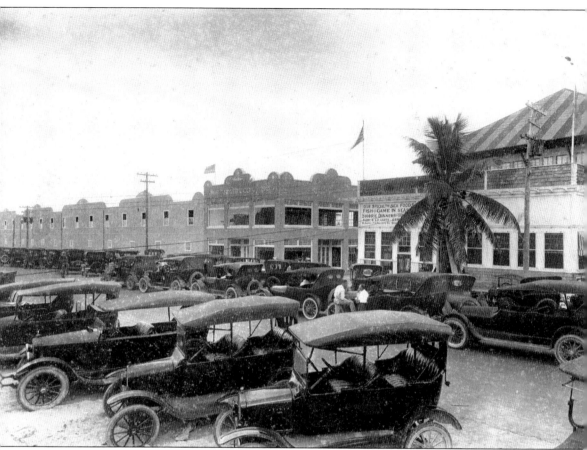

Smith's Casino Baths was the first of the Miami Beach bathing casinos, and it is likely that Joe Weiss, the Joe of today's Joe's Stone Crabs Restaurant, got his start at Smith's in 1913. On the right, a soft drink delivery truck is visible, and the sign on the building closer to the camera tells that Smith's Casino restaurant's specialty was "Sea Foods," with "Fish and Game in Season." The building on the left bears the legend "1908/Smith Co. Inc./1921." Those were heady times for a resort just beginning to feel its oats, and Smith's remained a mainstay of Miami Beach for many years.

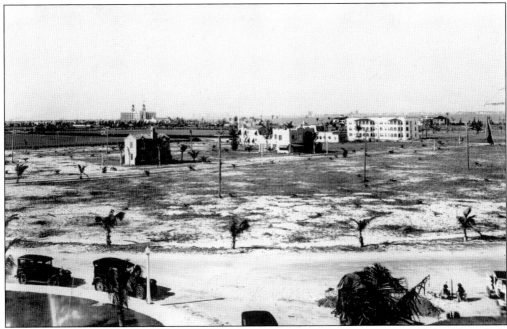

With the camera likely positioned on Forty-seventh Street at the entrance of the King Cole Hotel (later Miami Heart Institute), this view is north and east of the Nautilus Hotel. The hotel is in the center background, and just a few homes and apartment houses are in view.

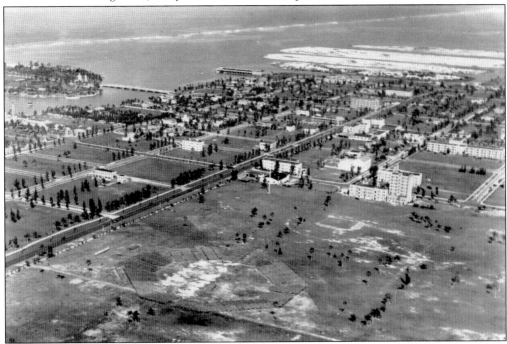

Here is another aerial view, this looking north and west toward the Venetian Causeway and Belle Isle, with the just-being-filled-in Sunset Islands in the center background. The large open area below is Flamingo Park and the wooden arena are all that remains from one of the great heavyweight championship bouts then held in Miami Beach but long since moved to Las Vegas.

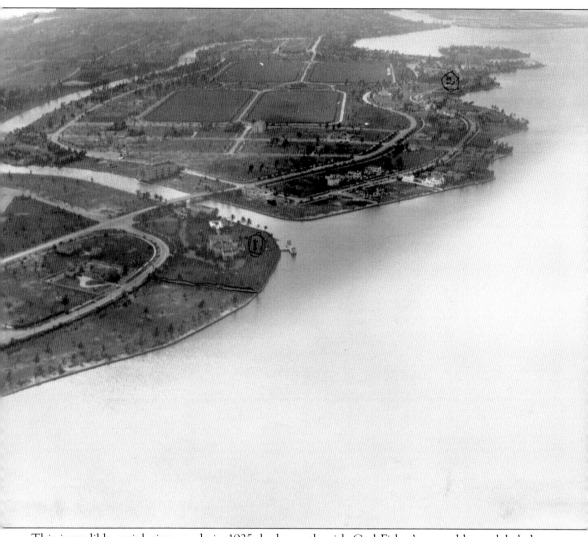

This incredible aerial view, made in 1925, looks south with Carl Fisher's second home labeled with the circled number one. The canal coming in from Biscayne Bay passed the King Cole Hotel, which was on Forty-Seventh Street. The Nautilus is on the right labeled with the circled number two. North Bay Road is the street in front of Fisher's home closest to the bay, and the triangular plot just east of his home is where the monument honoring him would be erected following his death in 1939. The great polo fields are to our right. Today homes, Nautilus Middle School, and Polo Park occupy the site.

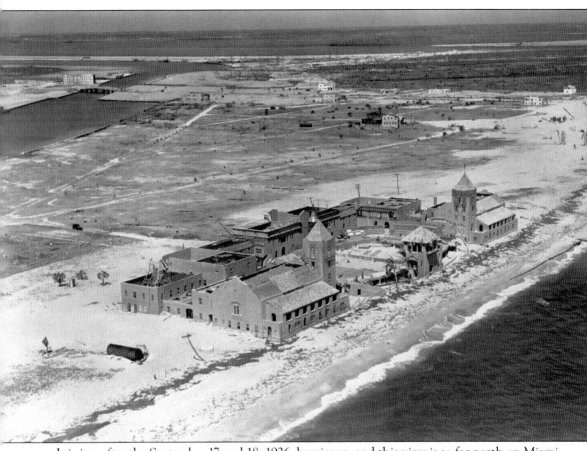

It is just after the September 17 and 18, 1926, hurricane, and this view is so far north on Miami Beach (at that time) that it was laughable to think that anybody would move "up there," as for many years, Dade Boulevard, just a few blocks north of Lincoln Road, was as far as you went. The Deauville Hotel (later MacFadden Deauville after it was purchased by the great tennis player and health enthusiast Bernarr MacFadden), at what was later Sixty-seventh Street and Collins Avenue, was under construction when the hurricane hit. Collins Avenue is covered with sand in this image, and the telephone poles at right are badly bent.

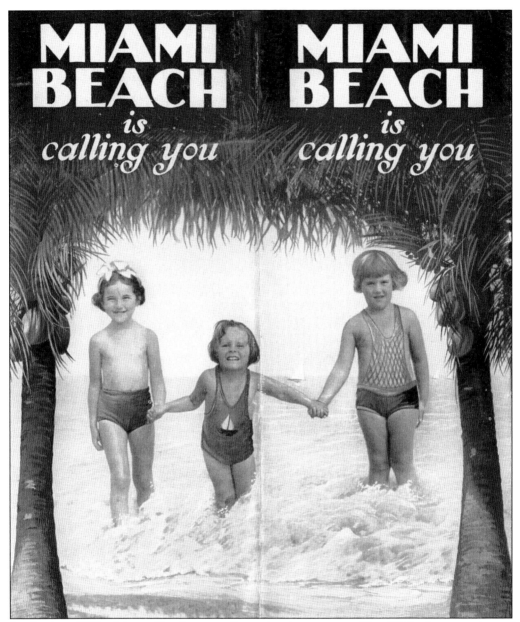

In the late 1920s, Miami Beach was calling the American public. With the exception of California, no state's municipalities published promotional materials as gloriously stunning as those done by the cities of South Florida. With the children coming out of the surf framed by palm trees, Miami Beach was calling to America in the dead of winter, and this booklet, published by the Miami Beach Chamber of Commerce, extols the glories and the beauties of Carl Fisher's city.

THE LURE of MIAMI BEACH

The children pictured in the booklet on the previous page were irresistible, and the message was very clear: bring your children, bring your families, bring your money, and bring yourselves to Miami Beach. Come by car or train or boat, but come. The striking photographs inside this rare booklet illustrate a growing resort in all its glory with the then-new Ida M. Fisher High School (later becoming a junior high of the same name, the high school name being changed to the beloved Miami Beach High) and its open air patios showing the superiority of schooling in the tropics, while numerous other photographs show sports, swimming, hotels, and city scenes, all marvelously inviting and obviously hard for the prospective vacationer of the time to resist.

Three

DEPRESSION AND DECO
Almost Untouched
by the Bad Times

The harbinger of the Great Depression, which began for America in 1929, actually occurred at the entrance to the Miami harbor in 1926, when the four-masted schooner *Rose Mahoney* turned over and blocked the harbor entrance for weeks.

Though the "official" start of the Great Depression was three years in the future, the handwriting was on the wall, and while the 1920s continued to boom, the economic clouds were darkening. When Black Monday hit the New York Stock Exchange and the Depression began, Miami Beach, although feeling the pinch, did not even begin to suffer at the level of cities and communities that depended on manufacturing or mining. Rather, incredibly enough, business, while dipping, remained relatively close to what it had been, at least on the beach.

The 1930s saw the beginning of art deco as the style in numerous hotels and apartment houses, and there was a surprising amount of construction during this time. Hotels were built, restaurants opened, and most importantly, people came.

Sadly on July 15, 1939, Carl Fisher died as the result of a gastric hemorrhage. Pete Chase was in charge of funeral arrangements, and Fisher's death made national news. Services were held outdoors in Collins Park at Twenty-first Street and Collins Avenue, and John Oliver LaGorce delivered the eulogy from the front steps of the Miami Beach Public Library with a huge crowd in attendance.

Almost immediately, fund-raising began for an appropriate memorial to the founder, and eventually the park at Fifty-first Street and Alton Road was decided upon as the location for what would be known as the Fisher Monument. The inscription reads, "He Carved a Great City From a Jungle," and because of the fabulous Hoosier, a great city was carved from a jungle. Carl Graham Fisher's name will remain immortal to anyone interested in the history of Miami Beach.

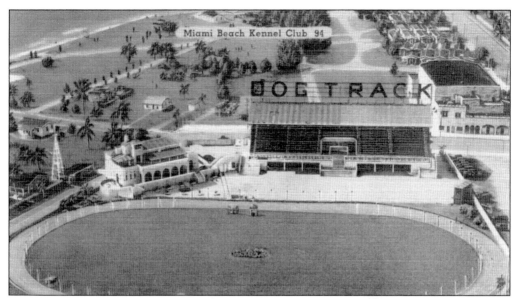

From 1926 until 1980, Miami Beach Kennel Club was a mainstay of the tourism business on the beach and in the county, and when the property was sold and the track torn down for more high-rise buildings, it was another major loss to all except the developers. This view looks west at the clubhouse with the Biscayne Plaza Theater (see page 41) on Biscayne Street to the right behind the K in the "Dog Track" sign and Government Cut ship channel to the left.

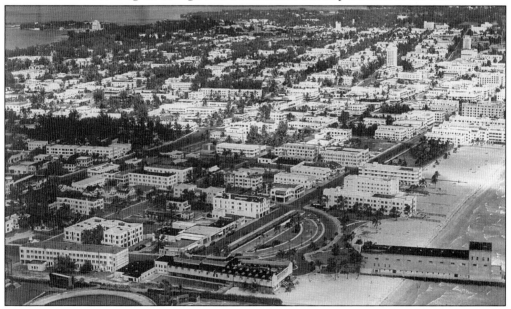

This is a late-1930s view of the city from above the Atlantic at the south end looking north. Smith's Casino is at the bottom of the photograph and the pier is to the right of that. The Shoreham, Norman, and Ocean Grande Hotels are the first three hotels on the beach from the bottom of the photograph. On the right side of the photograph, the high-rise building on the west side of Washington Avenue is the Blackstone Hotel with city hall farther up the street. On the left side of the photograph, the tall building several blocks in front of the Venetian Causeway looking north is the ubiquitous Flamingo Hotel.

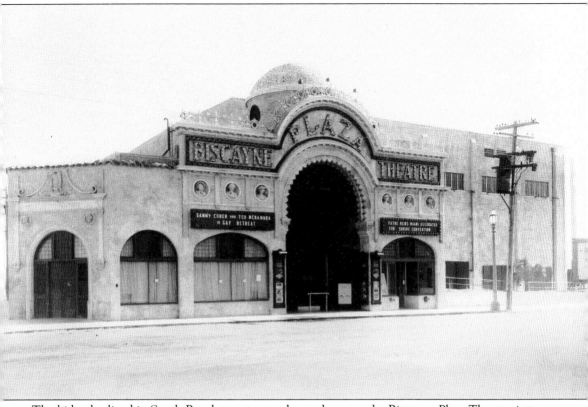

The kids who lived in South Beach spent many happy hours at the Biscayne Plaza Theater, just as others a little farther north went to the Cinema and the Cameo and, later, to the Beach, the Lincoln, and the Flamingo on Lincoln Road. A striking building that should have been preserved, it was a great architectural loss when the Biscayne Plaza, just west of the dog track on Biscayne Street, was torn down.

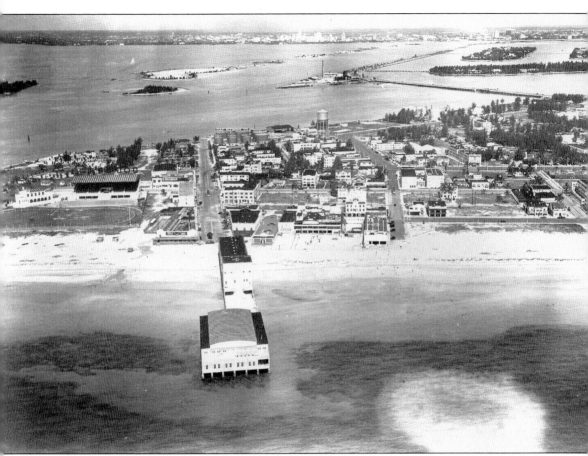

The pier was at the south end of Miami Beach, at the foot of Biscayne Street, the last, or farthest south, street on the beach. In its early years, the pier housed Minsky's Burlesque and Hackney's Seafood Restaurant along with other businesses, but lack of maintenance and deterioration from the elements led to the tearing down of most of it, so that today only an open fishing pier remains on the site. To the left is Miami Beach Kennel Club, and to the right of the track is the Biscayne Plaza theater and Smith's Casino, for bathing not games of chance. A close look will reveal a trolley car on Biscayne Street and another on First Street, two blocks north. The County (MacArthur) Causeway is visible as are its three islands—Star, closest to Miami Beach; and Palm and Hibiscus in the background. With the pier, the track, the Biscayne Plaza Theater, and Smith's Casino long gone, there is little recognizable in what is now a concrete canyon of high-rises.

Betty and Frank's Red Devil Restaurant, with the picture of the devil himself hanging at the rear, was at 163 Collins Avenue for many years. Now long gone, its existence is remembered by only a few of the real and true old-timers.

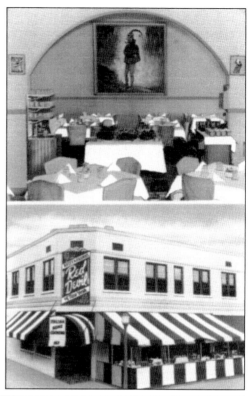

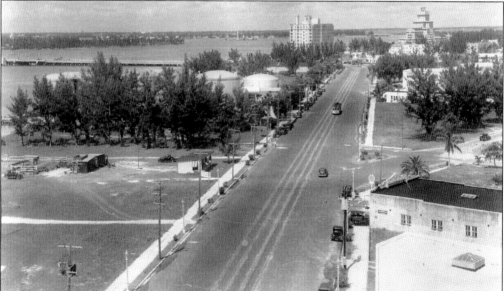

One of the hardest to find images for Miami Beach historians is anything showing a streetcar on the beach. Here, though, we note that a Miami Beach Railway Company trolley is northbound on Alton Road between Second and Third Streets, with South Beach Elementary School on the right and the Floridian Hotel on the left at the entrance to the County Causeway. To the right of the Floridian is the Fleetwood Hotel, and if we look carefully at the causeway, just to the right of the draw, we see another streetcar, this one likely headed east towards the beach.

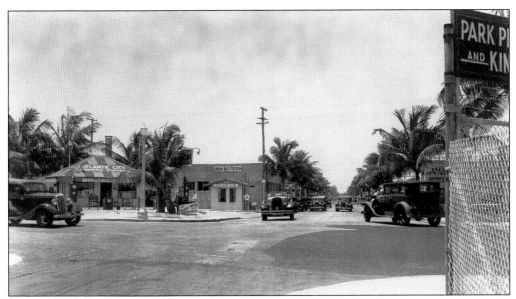

Looking west on Fifth Street from Ocean Drive, directly to the left and across the street, Mack and Mel's Atlantic City Service Station can be seen. Behind it is the Miami Beach Union Bus Station. Their services were eventually taken over by Greyhound when they built a new bus depot just south of Lincoln Road on Collins Avenue, adjacent to the airline ticket offices. Fifth Street has since been doubled in width and is now a major thoroughfare and the direct east-west street to and from MacArthur Causeway.

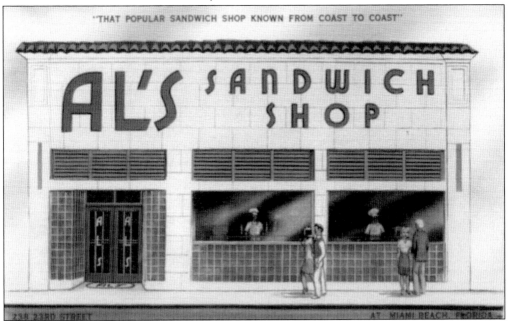

Al Nemets was a well-known Miami Beach sandwich and deli shop operator, and his concepts were those adopted by the late Wolfie Cohen when he opened Wolfie's and later the Rascal House. Besides having his own operations, Nemets managed for other owners and was a Miami Beach fixture into the 1970s. His first deli was at Fifth and Washington and his famous tag line was "Everybody meets at Al's."

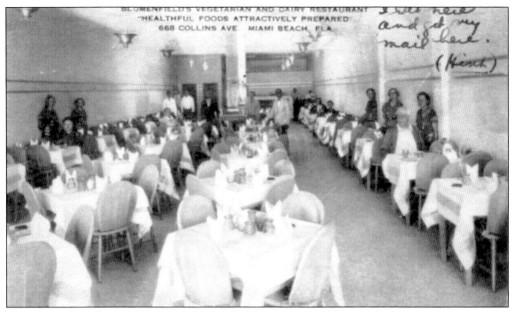

At a time when Miami Beach was rife with "restricted" hotels that declined to accept Jewish clientele, an ever-increasing number of Jewish people were moving to Miami Beach and buying property and businesses. Blumenfield's, at 668 Collins Avenue, was one of the first kosher restaurants on the beach. In this marvelous interior view, we see that the postcard writer sat at the table on the right and got her mail there. (She must have loved the place.)

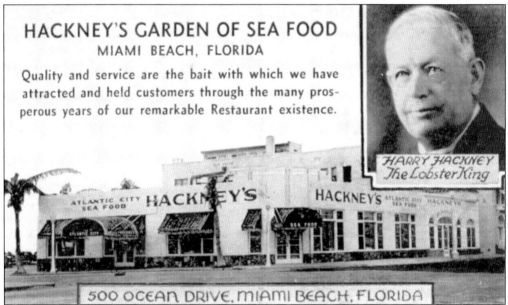

For years, what is now Joe's Stone Crabs Restaurant was just Joe's, and while it was always great, so was Hackney's, which started on the pier, moved to 500 Ocean Drive, then to the corner of Eighteenth Street and Alton Road (see page 69), and, eventually, to 133rd Street and Biscayne Boulevard in North Miami before closing up shop some time in the very early 1950s. Hackney's, of course, was a famous Atlantic City eatery, and Harry Hackney was the "lobster king." Shore dinners were a specialty. Neither Harry nor the restaurant are still around.

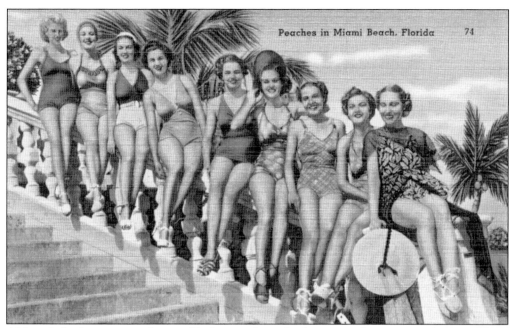

Although bathing suit styles would change through the years, the pretty girls were like a melody that for years would entice Northerners and Midwesterners, tired of sleet, snow, and frigid temperatures, to haul themselves to Miami Beach. The weather was lovely, the girls were beautiful, and nothing could mar the enjoyment of a vacation on, in the words of author Polly Redford, the "billion dollar sandbar."

The Stone family, tired of and insulted at being told that they were not welcome at certain "restricted clientele" hotels, built the first high-rise Miami Beach hotel, right on Washington Avenue. The Blackstone was, for many years, the hotel of choice for vacationers, regardless of their religion.

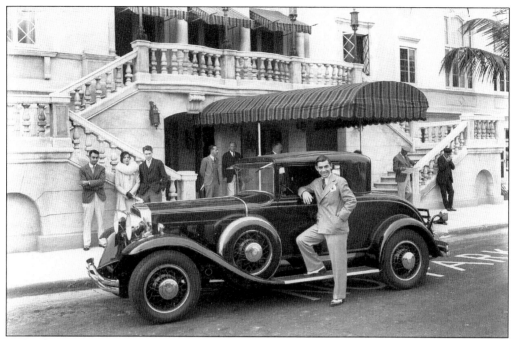

Is that handsome young swain with one leg jauntily perched on the running board in front of the Edward Hotel Clark Gable? One can't be certain, but it's easy to think it is. Gable came to the beach several times in the 1930s to enjoy both the glorious weather and, prior to his marriage to Carole Lombard, the bathing beauties.

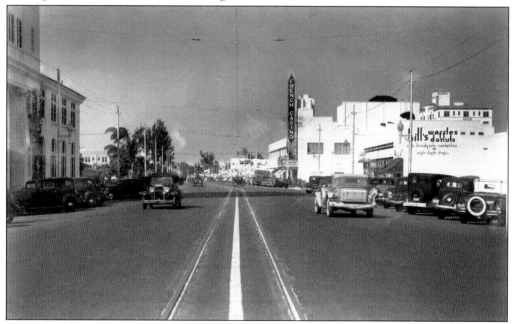

Miami Beach City Hall is on the left; the French Casino (later Cinema Theater) is on the right; the Alamac Hotel is in right background; and Bill's "Waffle Daffle" shop is in the right foreground. Happily, because the car to the right of the streetcar tracks has a 1936 license plate, we are able to accurately date this great image.

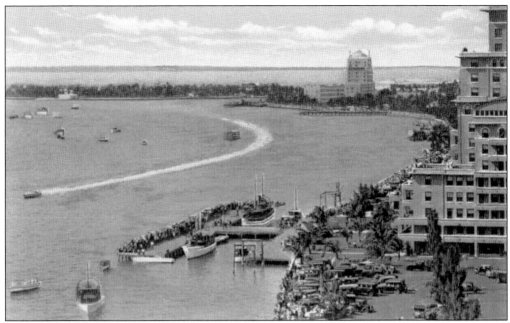

Miami Beach was the home of winter speedboat racing, and nobody typified or personified the sport better than Gar Wood. He is shown here roaring past the Fleetwood Hotel at almost 100 miles-per-hour in his famed *Miss America*. The Venetian Causeway is in the background

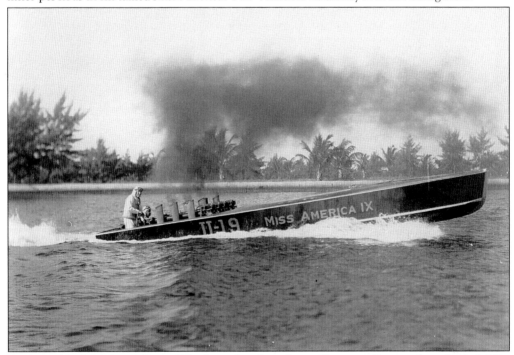

A close-up of the boat shows Wood at the throttle on Biscayne Bay, as he wheeled *Miss America IX* around for another run. For close to 20 years, Gar Wood was the American speedboat record holder, and he was nationally known both for his exploits and his association with Miami Beach.

Carl Fisher was famed as an automobilist and revered a railroader and hotelier. But Fisher built the single greatest monument outside of St. Augustine that commemorates the life of Florida's empire builder on an island that he created in Biscayne Bay between the County (now MacArthur) and Venetian Causeways. The central spire is surrounded by four statues, one on each side, each noting a different accomplishment of the immortal Henry M. Flagler. "Pioneer," "education," "industry," and "prosperity" testify to the greatness of the man who was not just identified with Florida but who, even in his own lifetime, was Florida.

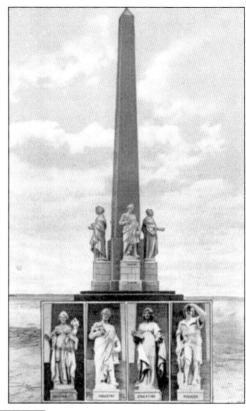

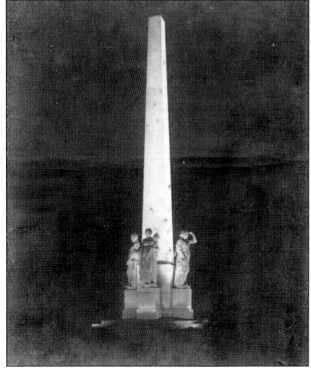

A dramatic nighttime view of the Flagler monument shows "Prosperity," with "Pioneer" to the right and "Industry" to the left. "Education" is on the other side, not visible in this view. The island and monument are maintained by the City of Miami Beach, and each evening, the statuary is lit by floodlights.

49

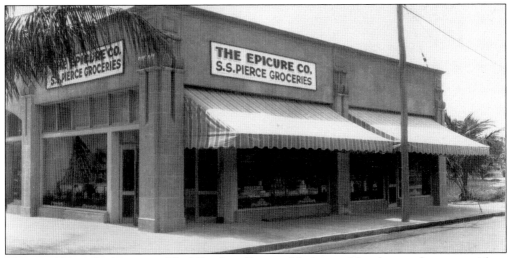

This would later be known as Thal Brothers Epicure Market and has been a fixture on Alton Road just north of Lincoln since the Thal family purchased the market in 1945. Before they took it over, it was on Washington Avenue, and to the best of our knowledge, this is the only known image of the store before it was moved to its present location.

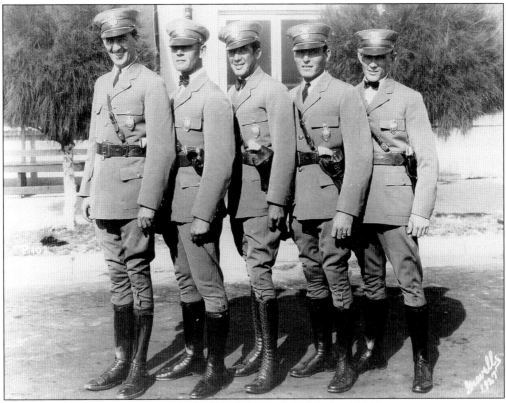

"Cheez it, the cops." In 1927, with the beach booming after the 1926 hurricane, city manager Claude Renshaw ordered motorcycles for the police department. This group of handsome young devils were "Miami Beach's finest," as they posed in front of the longtime police headquarters at 100 Meridian Avenue before mounting their bikes.

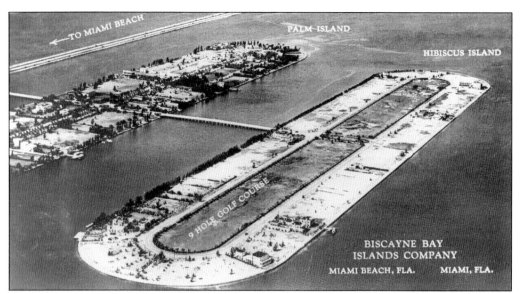

Prior to the various islands being pumped into the bay, it was magnificent and pristine, but shortly after the Biscayne Bay Islands Company completed their filling and dredging operations, Palm and Hibiscus Islands emerged. Palm, on the left, was the site of the fabled Latin Quarter Club and was the place for the high rollers of the 1930s and 1940s. Other than the club, nothing commercial was allowed, and both islands became famous for their beautiful residences and flora. County Causeway, with Watson Island just a spoil bank, and the city of Miami are in the background.

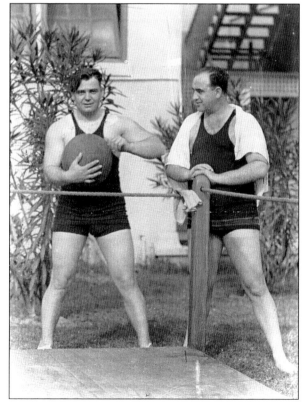

He was known, in polite circles, as the big man, Mr. Big, or Al Brown, but those who felt no affection for Al Capone would refer to him as Scarface or Snarky. When he bought a home on Palm Island, he was a cause celebre in the county and was warned against nefarious activities in Dade County by the state attorney, the mayors of Miami and Miami Beach, and the county sheriff, among others. Leading a peaceful life in Miami Beach, Capone enjoyed parties and family visits at his home, and he is shown here (right) at the Star Island House, with a man believed to be his brother. The resemblance is both strong and familial.

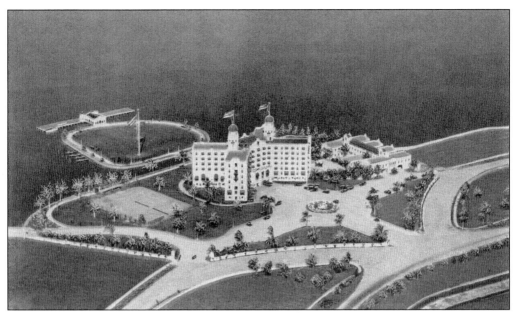

A marvelous and close-up aerial view of the Nautilus Hotel shows Alton Road in front and one of the two islands behind. To the right is the dormitory building that became the nurses' living quarters when Mount Sinai Hospital was founded after World War II. The two islands have been filled in, the buildings are gone, and today the giant Mount Sinai Medical Center provides superior health care for local residents.

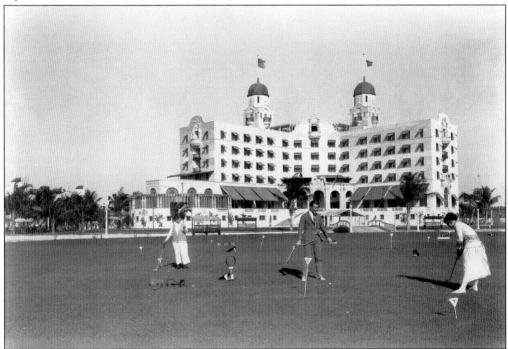

Behind the Nautilus was the nine-hole putting green course, later replaced by the hotel's swimming pool and cabana club. This view is east toward the building and is from the opposite side of the other photograph on this page.

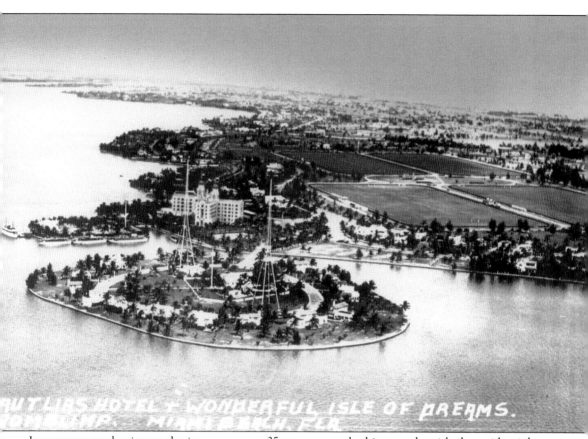

NUTLBS HOTEL & WONDERFUL ISLE OF DREAMS. ROME CAMP. MIAMI BEACH, FLA

In a reverse angle view to the image on page 35, we are now looking north, with the residential island of the Nautilus Hotel closest to the camera and the swimming pool island directly behind the hotel. For many years, the family of Samuel Gertner, founding executive director of Mount Sinai Hospital, which took over the hotel after World War II, lived on the island, and his son Bernard and daughter Linda went to Nautilus Junior High School and played at Polo Park, both built on the site where the polo fields are shown in this view.

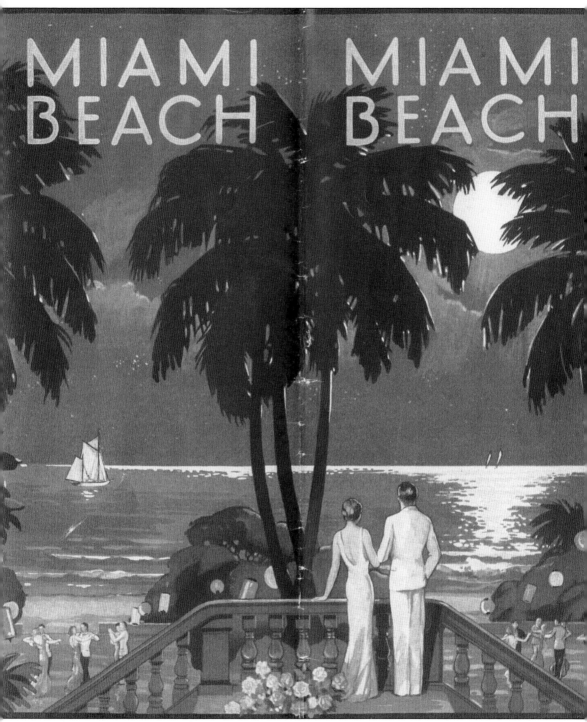

There is nothing that says "Miami Beach" more strongly or more beautifully than the stunning art deco cover of this 1936 chamber of commerce publication. Who could resist the allure of this image?

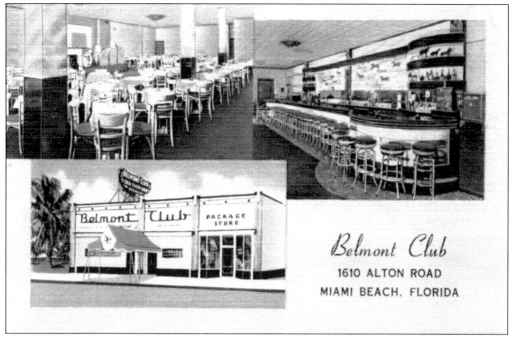

The Belmont Club was at 1610 Alton Road and was a real showplace, with live entertainment nightly at 11:00 p.m. and 1:00 and 3:00 a.m. Before the war and before the 1960s and 1970s business decline, places like the Belmont were jumpin'.

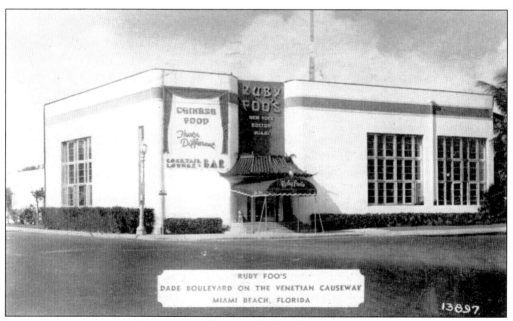

Ruby Foo's was a great favorite for Chinese food before Thai and Indian and Vietnamese became popular. Some Beachites vaguely recall the restaurant moving to Forty-first Street, but in any location, it is a happily remembered eatery at a time when the only Oriental cuisine available was Chinese.

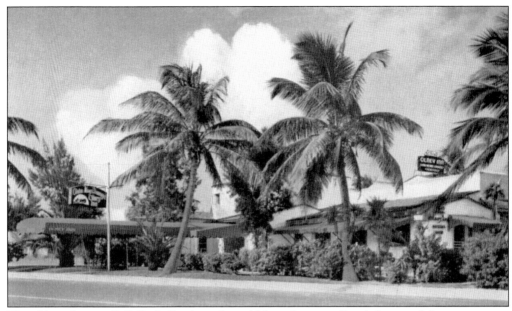

The Olney Inn at 1045 Dade Boulevard would later become Gray's Inn, and for many years, both were a favorite with Miami Beach diners.

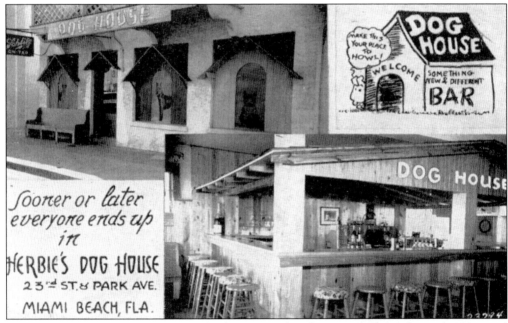

Herbie's Dog House was on Twenty-third Street and Park Avenue. From the mid-1930s until the mid-1950s when the American plan in the hotels gave guests breakfast and dinner, the area of Miami Beach from Twentieth to Twenty-third Streets and from Collins west to Liberty and Park Avenues was a true "tenderloin," with great restaurants, fabulous night clubs, and strikingly beautiful showgirls. Between the hotel dining, the introduction of condos to the beach, and the rise of Las Vegas, the area, with no casino gaming to support it, eventually faded completely. Today there is nothing there at all to indicate that some of the greatest restaurants and clubs in the nation were in that six-square-block area.

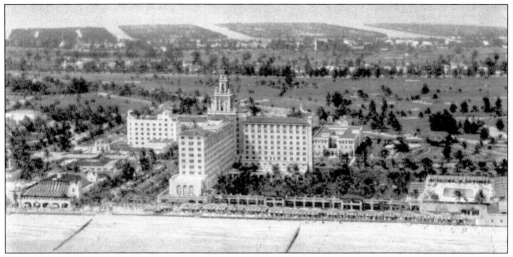

When the Roney Plaza was built on the full block between Twenty-third and Twenty-fourth Streets and between Collins Avenue and the ocean, it eclipsed anything that Miami Beach had seen up to that point. Until the opening of the Fontainebleau in 1954, the Roney was the grande dame of Miami Beach hotels, and with her magnificent gardens, huge swimming pool and cabana club, outdoor oceanside promenade, dining, and access to the sightseeing boats that left from the "Roney docks" directly across from the hotel on Lake Pancoast, it was the place to see and be seen. Burdine's, the famed South Florida department store now part of Macy's, opened their first Miami Beach outlet there and for many years was open only in the winter. Duke Stewart, beloved Roney manager, along with the late Jack Stubbs, who operated the cabana club, would leave the Roney in 1954 to take the same positions at the Fontainebleau, where they were both fixtures for almost 20 years.

The Roney Plaza is on the left, and the Helen Mar Apartment Hotel is on the right in this view looking south on Indian Creek. Indian Creek Drive is on the left. Except for the street and the waterway itself, little if anything visible in this view remains today.

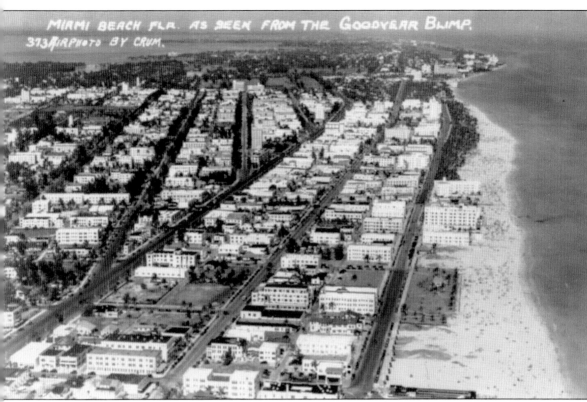

MIAMI BEACH FLA. AS SEEN FROM THE GOODYEAR BLIMP.
373 AIRPHOTO BY CRUM.

Looking north from the Goodyear blimp, we can see the beach beginning to develop, as the area south of Lincoln Road is almost completely filled in and signs of development are showing farther north. Although the Art Deco District has caused the preservation of many of the buildings on Washington and Collins Avenues and on Ocean Drive, the face of Miami Beach has changed dramatically since this *c.* 1936 photograph was made.

"Ocean Front Luxury at Low Cost" was available, provided one was not of the Jewish faith, for certain hostelries had the mistaken impression that advertising that they allowed only gentile clientele would be good for business. The Patrician, at Thirty-sixth Street and Collins Avenue, not only stated on the cover of the brochure that their clientele was strictly gentile, but when the brochure was opened to reveal the $1 per day per person rate, a large block on the right panel noted clearly that they catered only to "Refined Clientele," another exclusionary catchphrase.

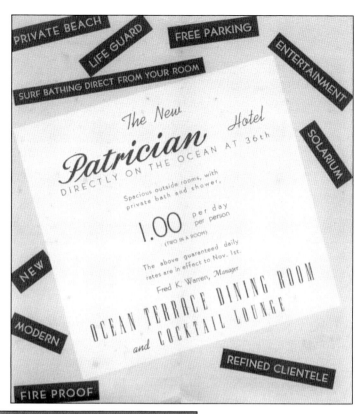

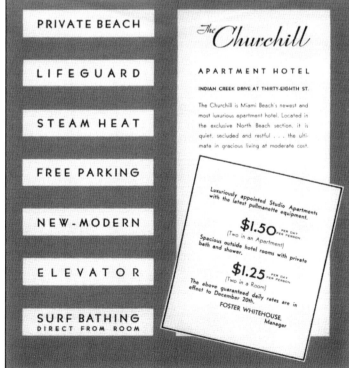

The Churchill Hotel at Thirty-eighth Street and Collins Avenue was beautiful and new in the late 1930s, but it made no bones about its "gentiles only" policy. Reprehensible though it was, the practice of discriminating against prospective Jewish guests (African Americans had not even a chance) was far from minimal and was used by no small number of the hotels on Miami Beach, in Surfside, and in Bal Harbour, both just north of Miami Beach.

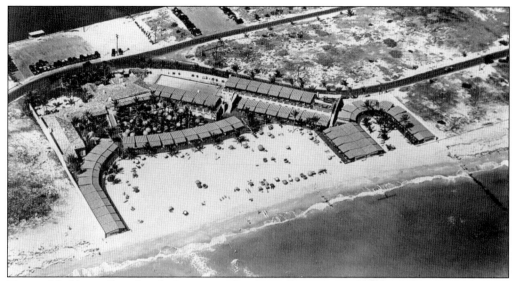

To avoid "rubbing elbows" with those considered socially unacceptable, several private clubs were created that excluded any person of Semitic origin, refusing to accept Jews as members. About the only known exception was the great 1950s socialite Marie "Mother" Gross. The three most blatant practitioners of the policy were the Bath Club, at Fifty-ninth Street and Collins Avenue (shown here), the Surf Club in Surfside, and LaGorce Country Club on LaGorce Drive. Times have changed, however, and the Bath Club was sold to R. Donohue Peebles, a black man, for development as a hotel and condos. The Surf Club now welcomes Jewish members, and LaGorce is close to if not exactly half Jewish in its membership. Looking down on the Bath Club, the point at which Collins Avenue divides can be seen. Collins continues north past the club and Indian Creek Drive follows Indian Creek north to Seventy-first Street. The club is now gone but is another memory of a different, and earlier, Miami Beach. (Courtesy "Miami Mike" Hiscano.)

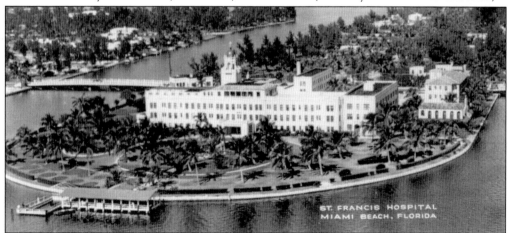

Four blocks north of the Bath Club is Sixty-third Street, and it was here that Fisher's close friend from Indianapolis, Jim Allison, built both Allison Island and the hospital that bears his name. The hospital would eventually be deeded to the Sisters of St. Francis, who for many years operated a fine health care institution. Changing times, an aging physical plant, and a dearth of patients brought an end to the facility. The city allowed the property to be sold for housing, and on the site today are high-rise condos and low-rise apartments, dwarfing the beautiful homes that were built on the island and creating nearly unbearable traffic conditions in the area.

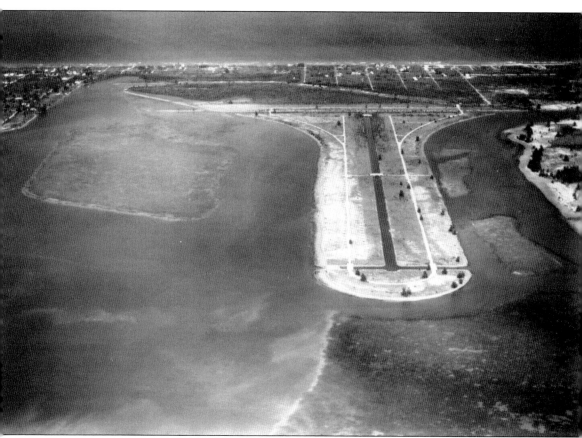

In 1947, the Bramsons moved from South Beach to 8035 Harding Avenue and, a year and a half later, to 840 Eightieth Street on Biscayne Beach. Early in 1950, Mrs. Sally Bramson, driving around the neighborhood, motored across the little bridge over the canal at Eighty-first Street and onto Biscayne Point, where at 8035 Cecil Street she saw a house under construction with a sign that read: "Vets. No money down." She called her husband at work, and the couple bought the house on the spot. Sometime in the late 1930s, what would become Biscayne Point was filled in, and looking east at the island, Biscayne Point Circle can be seen at the rounded end, with the Henedon Avenue bridge midway in the view connecting both sides. (Biscayne Point is actually three individual islands.) In this photograph, not a single dwelling has been built yet. It was recently learned that the two block-long streets, Cecil on the north side and Fowler on the south side, each one block west of Noremac Avenue, were named for Carl Fisher's friend in Indianapolis, Cecil Fowler. It is still unknown who Henedon or Noremac were named for.

Jane and Carl Fisher named their home the Shadows, and when it was first built, with the trees and shrubs barely sprouts, there was nary a shadow to be found. After several years, the growth was lush, and though the home on Collins Avenue was striking and expansive, Carl wanted an even bigger place.

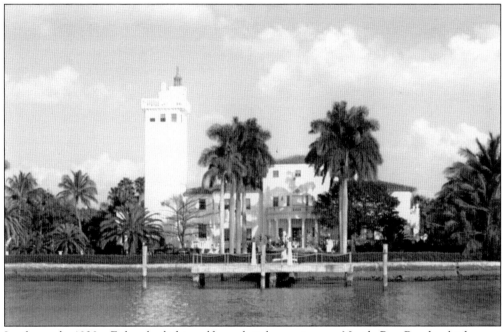

In the early 1930s, Fisher built himself a palatial mansion on North Bay Road, which even today, is Miami Beach's "millionaire's row." His house, with its three stories and tower, was for many years the largest private home on Miami Beach.

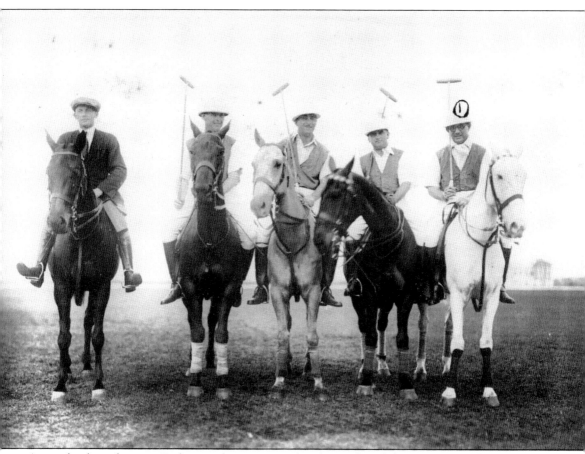

An avid polo enthusiast, Carl was right on target when he predicted that Miami Beach, with its tropical weather, could and would be an international polo mecca, and for many years, it was. Here, at far right, he sits astride his beautiful white horse preparatory to a match.

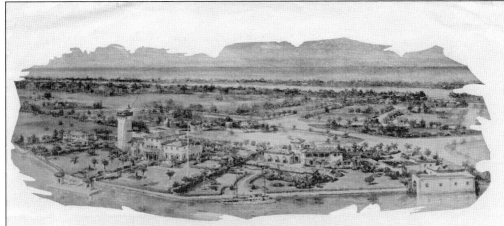

A CONCEPTION OF THIS EXTENSIVE PROPERTY, DIVIDED INTO THREE MAGNIFICENT ESTATES

The Carl G. Fisher
Bayfront Estate
at MIAMI BEACH

With the Depression in full sway, Fisher found it necessary to cut back on his extravagant lifestyle, and with plans underway to develop Montauk, Long Island, as a summer resort, money, which was in short supply, had to be raised. Much to his distress he was forced to sell Shadows II, shown in the lower photograph on page 62. The property was so immense that it had to be sold in four sections, and this brochure, an extremely rare piece of Miami memorabilia, tells the full story of the property and what would be sold.

WESTERN UNION (21).

1201

R. B. WHITE
PRESIDENT

NEWCOMB CARLTON
CHAIRMAN OF THE BOARD

J. C. WILLEVER
FIRST VICE-PRESIDENT

The filing time shown in the date line on telegrams and day letters is STANDARD TIME at point of origin. Time of receipt is STANDARD TIME at point of destination

NAC155 8=TDMZ MIAMIBEACH FLO 15 508P

1939 JUL 15 PM 5 35

C W CHASE JR=

HOTEL ASTOR=

SORRY TO REPORT MR FISHER JUST PASSED AWAY=

VIRGINIA SCOTT.

Carl Fisher died on July 15, 1939. A series of telegrams between Pete Chase and Fisher's office followed Fisher's death. Chase was at the Astor Hotel in New York City on Fisher Properties business, and shortly after 6:00 p.m. that day, he was handed this telegram reporting that Mr. Fisher had died.

John Oliver LaGorce eulogized Fisher several days after his death on the front steps of the Miami Beach Public Library (later the Bass Art Museum) surrounded by flowers and facing an audience that filled the entire park.

In 1919, when this photograph was taken, Carl Fisher was in his prime. Handsome, gutsy, willing to take great risks, and very wealthy, he was putting his life and fortune into building an island city. Almost everybody who knew him tried to deter him, but with Jane at his side, he would not be swayed. Because of him, the story of Miami Beach is as much legend as it is fact.

Twenty years later, the hard life, the drinking, and the risks were all showing on Fisher's countenance, and in this photograph, taken just a few weeks before the hemorrhage that would kill him, shows a much older, worn, and different Carl Graham Fisher.

Four

WAR CHANGES EVERYTHING

Mercifully the Great Depression was coming to an end, and the pulse of the nation was quickening as production resumed and men and women went back to work. Unhappily though, the clouds of the greatest conflict in human history were on the horizon, and within days of the Japanese attack on Pearl Harbor, mobilization was in full swing.

The army moved quickly to take over most of the hotels on the beach, while the navy did the same thing on the Miami side. As it turned out, more than 50 percent of the army's flyers received their basic training on Miami Beach, and the streets and parks were filled with men marching, practicing, and drilling.

Almost as soon as the war ended in 1945, a new "boom" began, and hotel building was evident from one end of the beach to the other, with such famous properties as the Martinique, Monte Carlo, Sea View, Crown, Delmonico, and others going up. That burst of construction would only intensify as the decade ended and the 1950s began.

After the war, Nautilus Elementary opened, and as students progressed through the grades, it became a junior high (now a middle school). Nautilus became the beach's second junior high, joining Ida M. Fisher—Carl Fisher was quoted as saying his mother, Ida, did not have a middle name, but he was so honored by the naming that it didn't matter—as one of two Miami Beach junior high schools.

All of the elementary schools (South Beach, Central Beach, North Beach, Biscayne, and, much later, Bay Harbor) fed into one of the two junior highs. Both of those schools sent their students to Miami Beach High School, which was, for many, many years and with the exception of Bronx High School of Science in New York, the number one rated academic public high school in America. Indeed, during those many years, "Beach was dynamite."

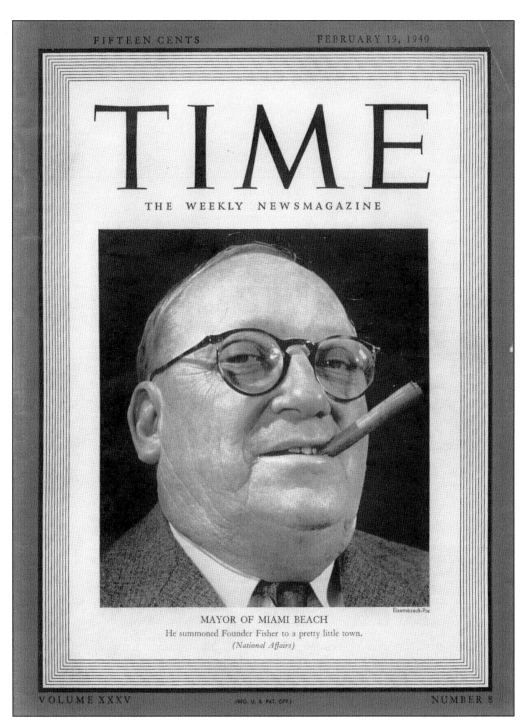

FIFTEEN CENTS FEBRUARY 19, 1940

TIME

THE WEEKLY NEWSMAGAZINE

Eisenstaedt-Pix

MAYOR OF MIAMI BEACH
He summoned Founder Fisher to a pretty little town.
(National Affairs)

VOLUME XXXV (REG. U. S. PAT. OFF.) NUMBER 8

John H. Levi was the man who brought Fisher to Miami Beach, and in the late 1930s, he became the long-serving mayor of the city. He was the first and only Miami Beach mayor ever to be honored by having his picture on the cover of *Time Magazine*, and the February 19, 1940, issue featured Miami Beach and Levi. Several pictures and a lengthy story told about the mayor, the founding of the city, and where the city was headed.

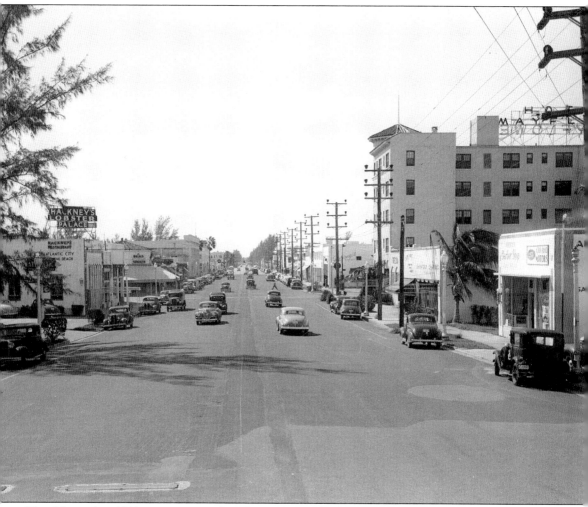

This November 1941 picture was taken from center of Alton Road, just on the south side of the Collins Canal looking down that broad street about a month before World War II began. Hackney's is on the left in its third Miami Beach location, and the First National Bank of Miami Beach is another block farther south, also on the left, on the northeast corner of Lincoln and Alton. On the right side of the street is where Epicure Market would move to between Lincoln and Seventeenth Streets. The hotel on the right—the Mayflower then, later the Variety, and now an apartment building—had, at the time of this photograph, the most inventive wording for its anti-Semitic flyers and brochures of any restricted hostelry. It advertised to prospective guests that the people who stayed there were "A clientele that's your sort."

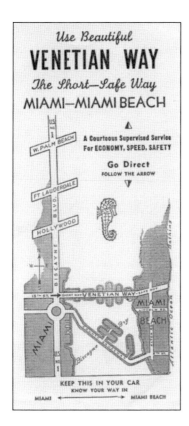

Use Beautiful
VENETIAN WAY
The Short—Safe Way
MIAMI—MIAMI BEACH

A Courteous Supervised Service
For ECONOMY, SPEED, SAFETY

Go Direct
FOLLOW THE ARROW

KEEP THIS IN YOUR CAR
KNOW YOUR WAY IN
MIAMI ←————→ MIAMI BEACH

The beautiful Venetian Way crossed six islands between Miami and the beach, and since a private company owned it for many years, the tollgates and all roadways were maintained. From time to time, the company issued brochures extolling the time savings inherent in using the causeway. Those folders are now considered gems by Miami collectors.

As the war came upon Miami Beach, hotels such as the Shelborne, at the corner of Eighteenth Street and Collins Avenue, were prime locations for dormitories, dining halls, and, with their card and meeting rooms, educational facilities. Later owned by the esteemed Galbut family, the hotel would eventually be enlarged to almost double the size of the building shown in this photograph with, of course, the land next door and across the street built on for as far as the eye can see.

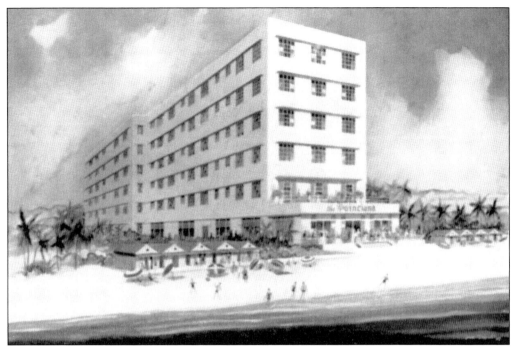

The Poinciana, one block south of Lincoln Road, was another hotel taken by the military "for the duration." Following the war, all hotels were returned to their owners with compensation for the army's usage of the properties.

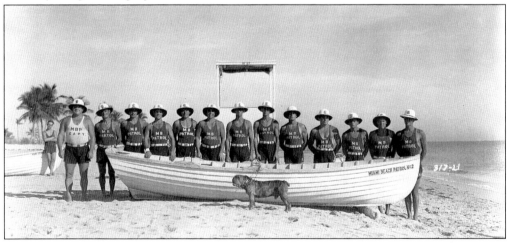

Even during the war, the Miami Beach Patrol, one of America's foremost lifeguarding corps, was on the lookout for errant bathers up and down the beach. Miami Beach's early fame as the water sports capital of America necessarily led to the city's establishment of a lifeguard division, known as the Miami Beach Patrol, or "beach patrol." Athletic, physically strong, and generally handsome young men would spend their days sitting in the lifeguard stands up and down the beaches, ogling the girls and being ogled by them, and in the days before sun blockers and a knowledge of the dangers sunlight poses to exposed skin, this hardy group of athletic-looking fellows—well, the captain on the left hasn't missed too many meals, and the pit bull mascot looks like a toughie—poses near the Tenth Street and Ocean Drive Patrol headquarters with lifesaving boat number two.

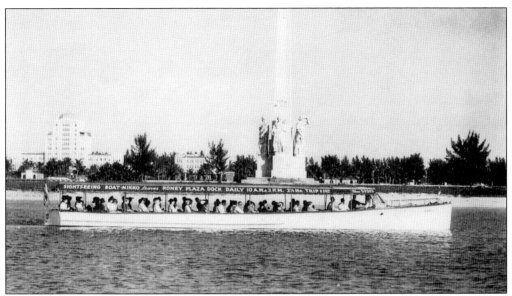

From time to time, the collecting of Miami and Miami Beach memorabilia yields hefty dividends, and finding this family album illustrates a marvelous scene, with the caption written by the tourist him- or herself, letting us know that the sightseeing boat *Nikko*, which sailed several times daily from the Roney Plaza docks opposite the hotel, was on a regular run in 1940 when it passes the Flagler Monument with the Flamingo Hotel in the background.

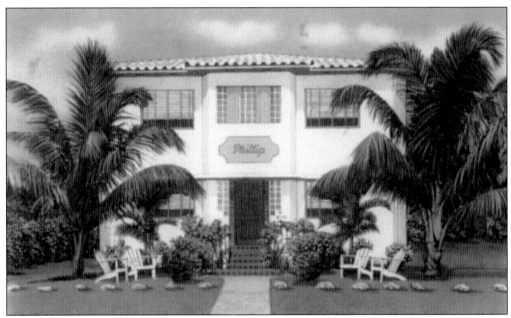

The Hotel Philip was at 6945 Abbot Avenue and was, according to this 1940s postcard, "Quiet and Restricted." The army would tolerate none of that silliness, and with only a very few exceptions, the policy of not allowing people of the Jewish faith to stay in hotels quietly disappeared by the end of the war.

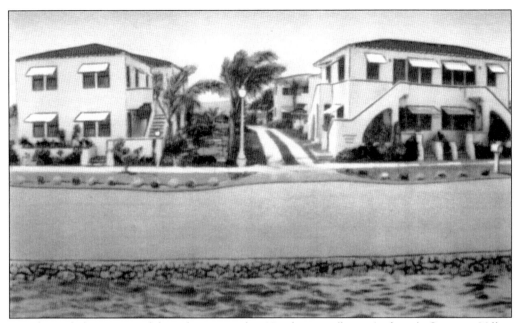

Another of the restricted hostelries was the Hutchinson (later Archway) Oceanic Villas, immediately north of the MacFadden Deauville. It was taken over by the army for use during the war, and no small number of extant images show soldiers in gas masks training on the wide beach directly behind the hotel.

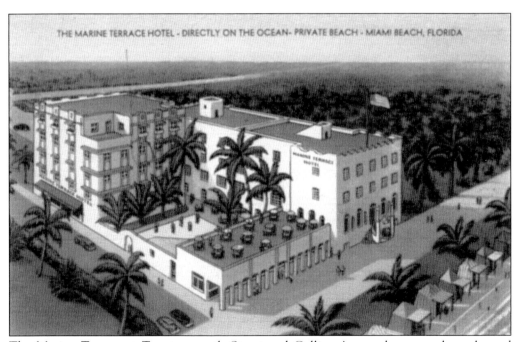

THE MARINE TERRACE HOTEL · DIRECTLY ON THE OCEAN · PRIVATE BEACH · MIAMI BEACH, FLORIDA

The Marine Terrace at Twenty-seventh Street and Collins Avenue became a barracks and dining hall during the war.

On South Beach, enjoying the glorious winter weather, Mary (on left) and Harry Meyers entertain their young daughter. The Tides Hotel is in the background on the right.

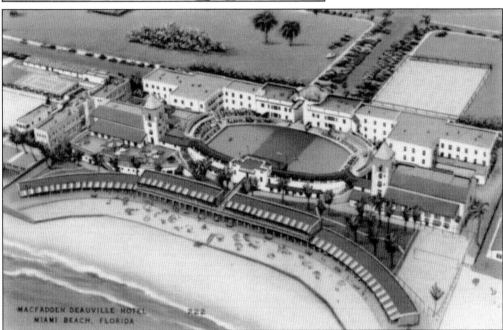

This is the MacFadden Deauville in all its glory in 1944. Sixty-seventh Street ends at the hotel, and eventually the fabled delicatessen restaurant Pumpernik's would occupy the lot where the tennis court appears across Collins Avenue from the hotel.

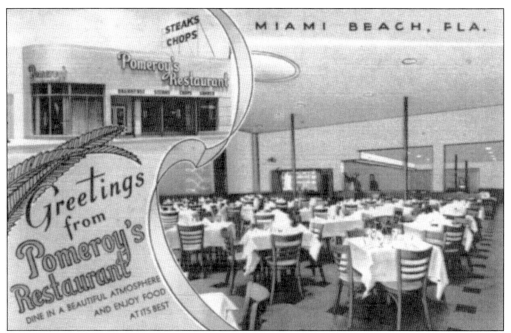

Pomeroy's, between Twentieth and Twenty-first Streets, is shown here. Unique because it was one of the few restaurants that was open all year-round in those days, it lasted until the early 1950s, closing as the neighborhood changed and guests took many more of their meals in the numerous new hotels opening up and down the beach.

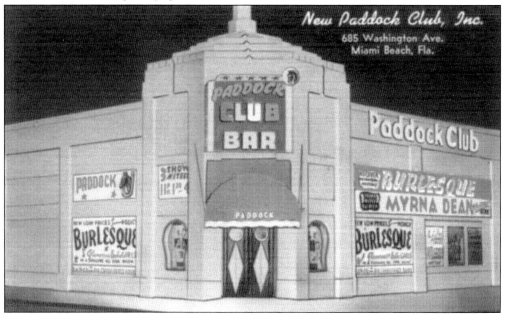

Sex sells, and the sexy burlesque dancers at the Paddock Club at 685 Washington Avenue, on the southeast corner of Seventh Street, drew big crowds in the 1940s. In this view, the featured dancer is the then-famous Myrna Dean, and while the burlesque of those days was tame compared to what is seen today, it was thought of as "scandalous," which is why it likely attracted so many men.

BEAUTIFUL DRIVE ON SUNSET ISLAND
MIAMI BEACH, FLORIDA
138

Miami Beach became a city not just of grand hotels and great schools but of beautiful homes. Sunset Islands was one of the city's finest private residential areas, and three of the four islands were restricted initially. This fine view shows a street on one of the islands, which were entered over a bridge at Twentieth Street and Alton Road.

35:—PURPLE BOUGANVILLEA, MIAMI BEACH, FLORIDA.

4567

North Bay Road was "millionaires row," and this striking entrance to one of the homes on that still beautiful street will gives an idea of the beauty of the area.

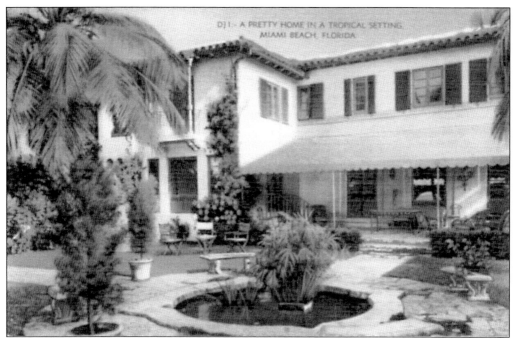

The caption on this card tells that this is "A pretty home in a tropical setting," but to Northerners weary of winter, it was an invitation to a lush paradise as a place to live, work, and retire.

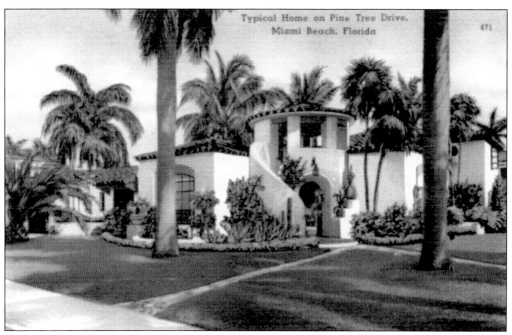

Pinetree Drive is still a beautiful residential street with elegant and now very expensive homes. It has received its share of publicity from the postcards of the 1940s.

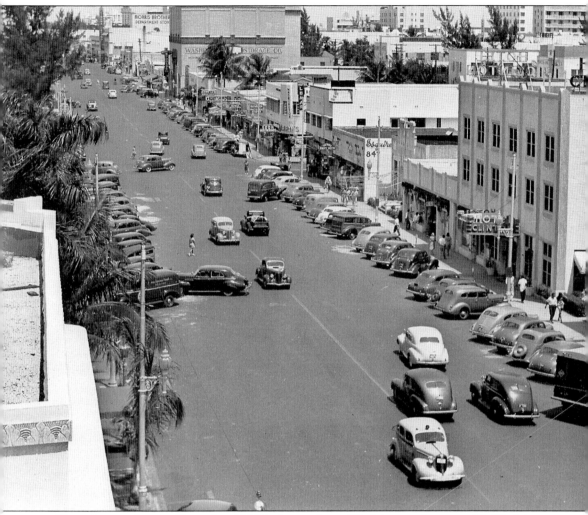

This picture taken in December 1940 looks north on Washington Avenue with Washington Storage at Tenth and Washington Avenue on the right. The building, with another floor added, is now the Wolfsonian-FIU Museum of the Decorative and Propaganda Arts, a magnificent building that houses the collection of the beloved Mitchell (Mickey) Wolfson Jr. The museum is now a major force in the worldwide preservation of the decorative arts, and Mr. Wolfson, the son of the late Col. Mitchell Wolfson, has become a revered presence in Miami-Dade County historical and social circles.

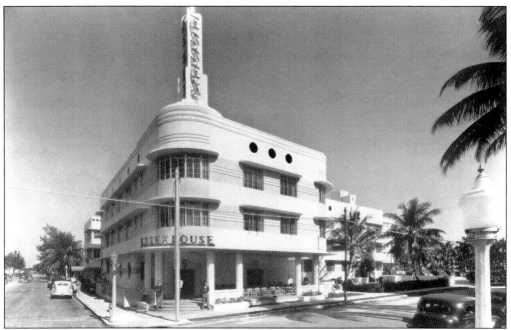

With its rounded corners, portholes, facia striping, and soaring name tower, the Essex House Hotel, on the corner of Tenth Street and Collins Avenue, remains a near pluperfect example of the unique design and underappreciated beauty of art deco architecture. The heyday of art deco's use as a favored building style came to an end with the coming of war and would not be resurrected until Barbara Capitman founded the Miami Design Preservation League. Capitman and her son, Andrew, worked tirelessly and endlessly to convince the city commission to preserve the entire district, which, to their unending credit, they did. That preservation was then seconded by the federal government, which has named the entire district a national historic district.

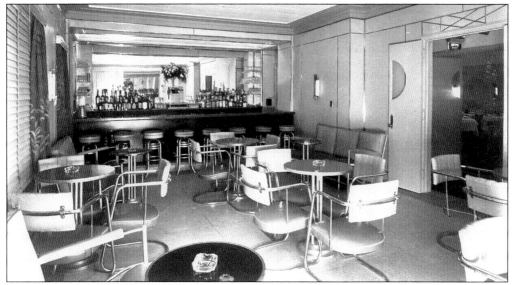

Fitting in with the art deco theme, the lounge of the Essex, adjacent to the dining room to the right, embodied all of the traits of the ignored and overlooked design style.

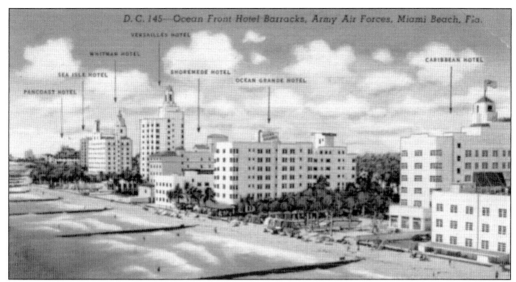

An important postcard for any Miami Beach historian or collector is this very unique view that points out and names the hotels between Twenty-fourth and Thirtieth Streets that the army took over for the war effort. From left to right, they include the Pancoast, the Sea Isle, the Whitman (later the Robert Richter, named by the family for a son who died in World War II), the Shoremeade, the Ocean Grande, and the Caribbean.

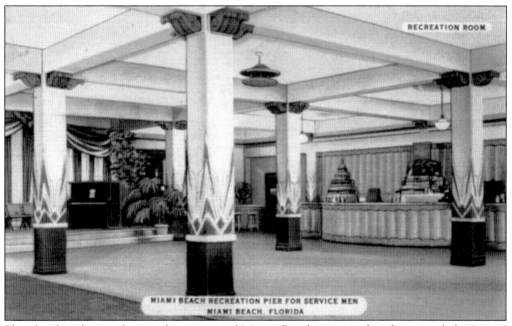

Shortly after the war began, the women of Miami Beach organized and operated the Miami Beach Recreation Pier for Servicemen, which was on the original South Beach pier. The facility was later moved to Tenth Street. Miami Beach's women, including the numerous beauties from Miami Beach High School, volunteered to hostess the servicemen, many of whom were from small towns and had never before been away from home. It was a warm and welcoming place, and a good few of the women married army flyers and other personnel, many of them either returning to or staying on Miami Beach after the war.

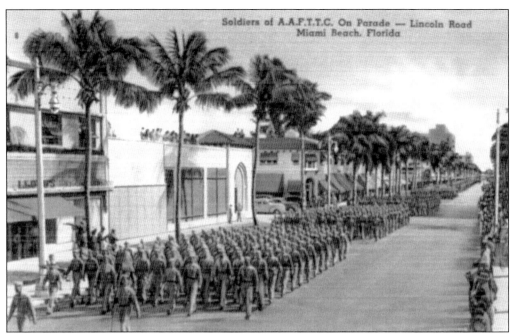

The army literally took over the beach. In this view, soldiers of the Army Air Force Technical Training Command march west on Lincoln Road.

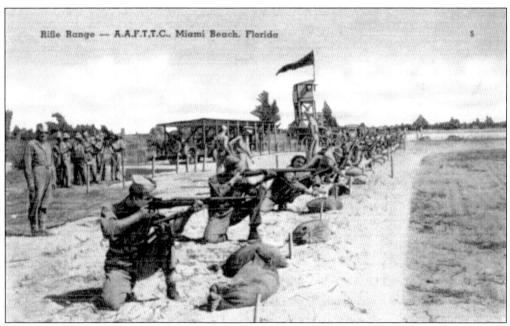

The rifle range was at the north end of the beach, likely north of Seventy-fifth Street, and that is where soldiers and flyers learned how to use the weapons they would carry. Even farther north on the site of what is now Bal Harbour Shoppes, the military police managed a German POW camp.

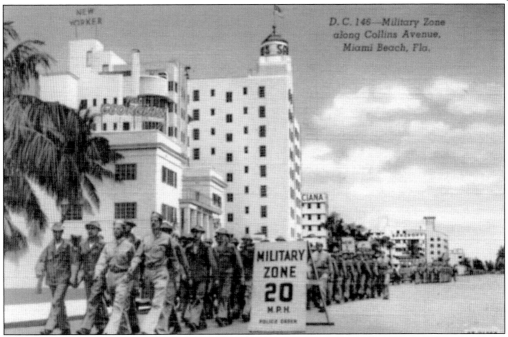

This image shows soldiers marching on Collins Avenue in the military zone. Much of the time, civilians were completely excluded from any streets or areas declared to be part of a military zone.

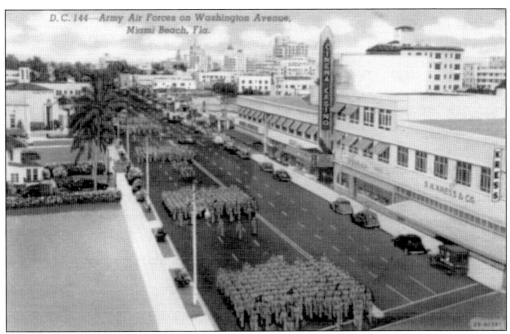

The soldiers are marching south on Washington Avenue. The Kress store, the Strand, and the Cinema Casino are on the right.

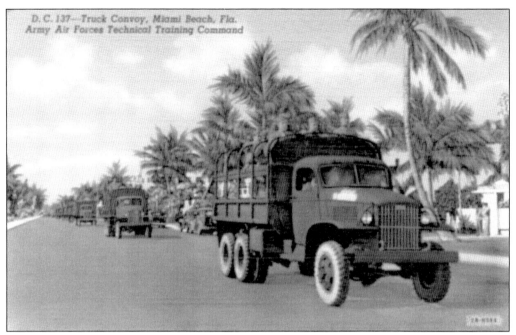

D. C. 137—Truck Convoy, Miami Beach, Fla.
Army Air Forces Technical Training Command

Truck convoys rolled through Miami Beach 24 hours a day. There was no let up as would-be pilots were put through six-month courses in six weeks. The urgency was felt nationwide but nowhere more strongly than in the city that would come to be known as the major army pilot training center.

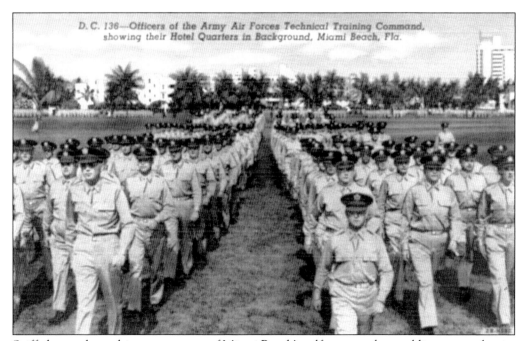

D. C. 136—Officers of the Army Air Forces Technical Training Command,
showing their Hotel Quarters in Background, Miami Beach, Fla.

Spiffed up and marching west on one of Miami Beach's golf courses, these soldiers are on the site that is now the location of the municipal parking lot, city auditorium, and convention center just north of Lincoln Road. The Shelborne Hotel is in the far right background.

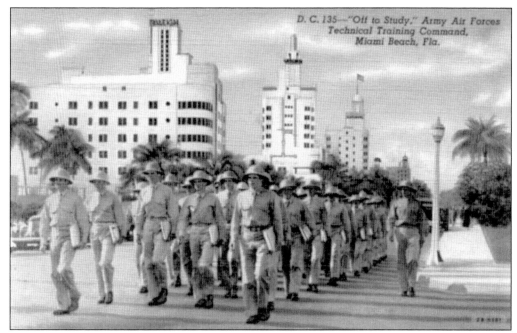

D. C. 135—"Off to Study," Army Air Forces Technical Training Command, Miami Beach, Fla.

Another view of the soldiers on Collins, this one a bit north of the view on page 82, shows the Raleigh, the Grossinger, and the National hotels.

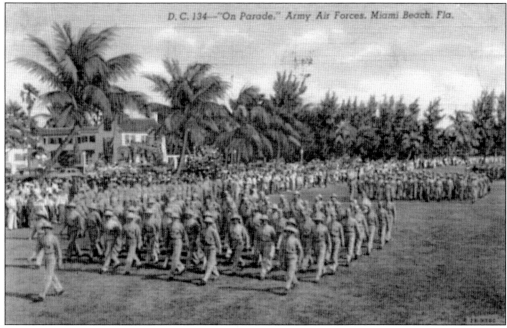

D. C. 134—"On Parade," Army Air Forces. Miami Beach. Fla.

Flamingo Park, still the city's largest public park, provided ample space for training and maneuvers. A favorite place was the Beach High football field (now called Memorial Field) as well as much of the rest of the acreage.

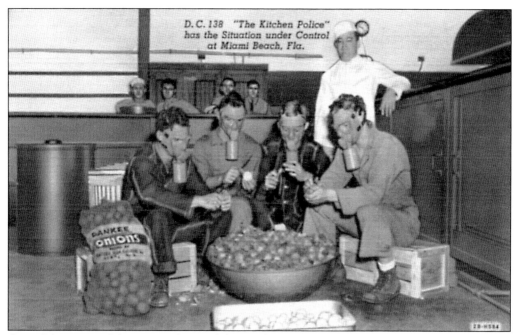

One of the rarest of the postcards issued during the army's stay on Miami Beach during the war, this totally unique view shows soldiers on KP duty wearing gas masks as they peel onions for the evening meal. The caption alone makes the card highly valuable to Miami memorabilia buffs. (Courtesy collection of Mitchell Rosen.)

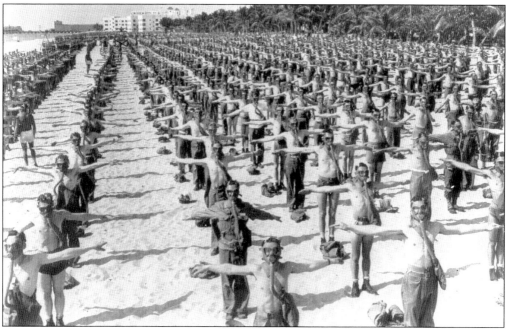

Soldiers stood shirtless in the broiling heat, often in shorts, wearing gas masks to learn how to protect themselves against enemy poison gas attacks. This marvelous photograph was taken in Lummus Park with the pier in the background. It is likely that loads of spectators stood behind the low coral rock walls on the right watching the training.

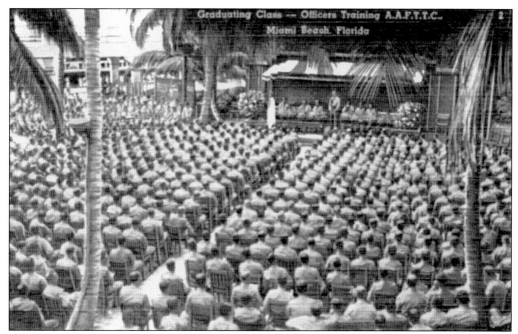

The big day for any class was, of course, graduation day, when soldiers received their commissions. Within just a few short days, they were off to their ports of embarkation for theaters throughout the world, across the Atlantic or Pacific. Many of these men would return to call Miami Beach home.

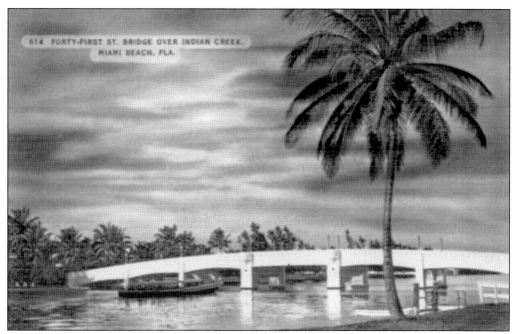

614 FORTY-FIRST ST. BRIDGE OVER INDIAN CREEK. MIAMI BEACH, FLA.

After the war, things slowly returned to normal. In this sunset view, several of the sightseeing boats from the Roney docks are out on their evening cruises. They are shown here crossing under the Forty-first Street bridge over Indian Creek.

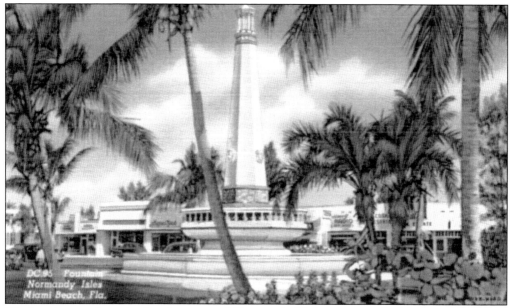

The beach moved north after the war, and Normandy Isle became an ideal location for a home or business. The fountain is still in the same location, and it often works! Although the stores behind the fountain are long gone, the building, with different names on the walls, is still there. Normandy Isle is the main island en route to North Bay Village, and the Seventy-ninth Street (John F. Kennedy) Causeway, which, until the Broad Causeway was built connecting Ninety-sixth Street on the beach side with NE 123rd Street on the Miami side, was the farthest north causeway in Dade County.

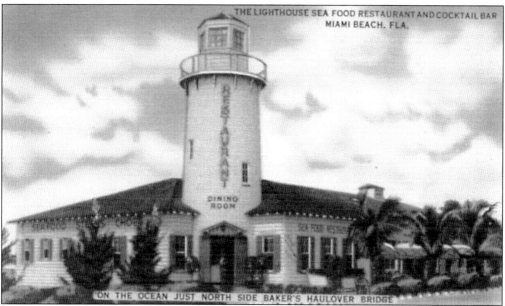

Just across the Haulover Inlet from Bal Harbour on the county side, the Lighthouse Restaurant stood for many years. Owner S. D. Macris maintained tanks full of fish and live turtles that the children would marvel at prior to their being removed for consumption. Until its destruction by fire in the late 1950s, it was a longtime Miami landmark and destination.

87

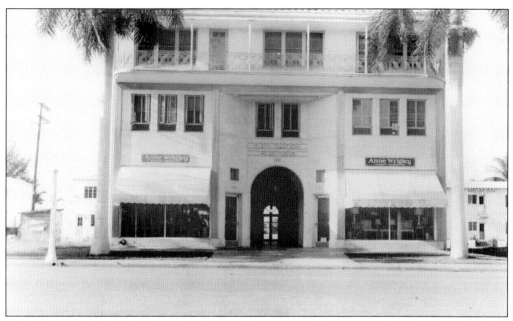

Built in 1927, the Bayshore Building housed the interior decorating offices of Anne Wrigley. It is thought that this building was on Forty-first Street, now Arthur Godfrey Road, as several people have commented that the third-floor balconies look familiar, but no one is certain that they are the same.

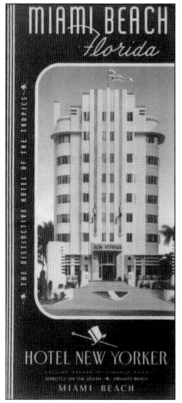

Just as the tearing down of Penn Station in New York was the catalyst for the preservation movement in that city, so the tearing down of the art deco gem New Yorker Hotel by then-owner Abe Resnick was a catalyst in Miami Beach. Resnick, who was also a city commissioner at one time, acted with complete disregard for both the historic importance of the building and the need to preserve this architectural gem. Though he later apologized, the late Mr. Resnick will always be remembered for the demolition that destroyed this striking structure.

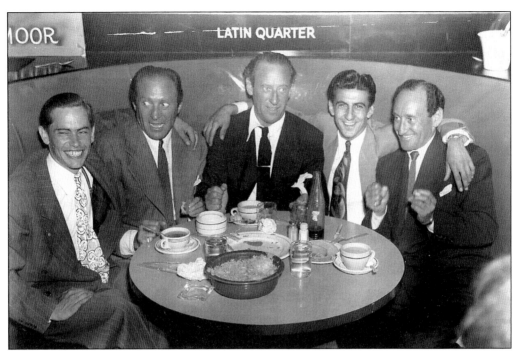

One of show business's greatest groups, the Ritz Brothers called Miami home beginning in the late 1940s. Shown here between shows at Lou Walter's Latin Quarter, the boys yuk it up for the camera.

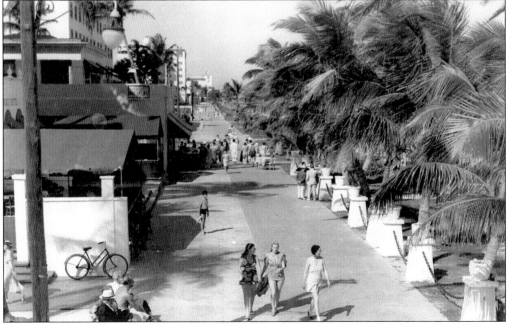

With peace restored, the two-block-long promenade from behind the Roney Plaza to Twenty-fifth Street was again the place to see and be seen, and many romances began there. Outdoor dining on hotel patios was a grand way to enjoy breakfast or lunch, and both hotel guests and residents made regular visits to and stops at the promenade.

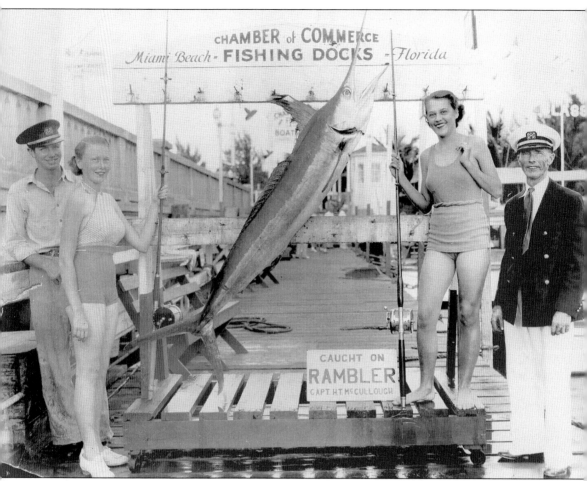

Although there were deep-sea fishing boats leaving from the Haulover docks, the so-called Chamber of Commerce Fishing Docks were famous for their boats, their captains, and the great catches at a time when sailfish, such as the one shown, could be legally caught, stuffed, and mounted. This happy group caught the fish on the *Rambler*, under the command of Capt. H. T. McCullough, shortly after World War II ended, when it was again safe to journey out to the fishing areas in the Atlantic off Miami Beach without worrying about German submarines, which torpedoed allied ships off Florida as late as 1943.

Beatrice Van Wye (left) smiles at us from her chaise lounge in front of her cabana at the Everglades Swim Club, which was originally built c. 1924 and had several name changes until the late 1940s, when it was the fashionable Everglades. In the background is the Roney Plaza, and we believe that it is Beatrice's sister ensconced next to her. Note the stunning coiffures on both of these beautiful women. (Courtesy Joy Van Wye Malakoff.)

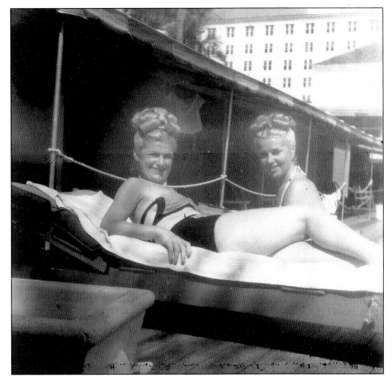

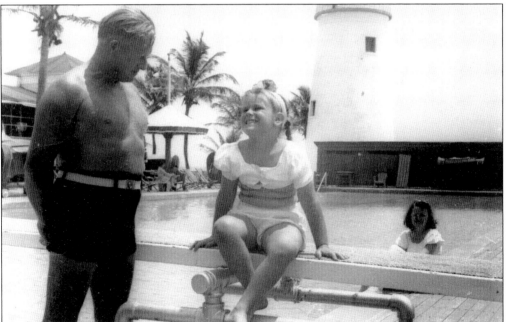

Joy Van Wye smiles warmly at longtime Miami Beach swimming instructor "Whitey." He certainly had a last name, but the habitués of the club knew him only by his nickname, and for many years, he was the premiere swimming instructor on the beach. In the background is the lighthouse and windmill, which was a trademark of the various predecessors to the Everglades Club. (Courtesy Joy Van Wye Malakoff).

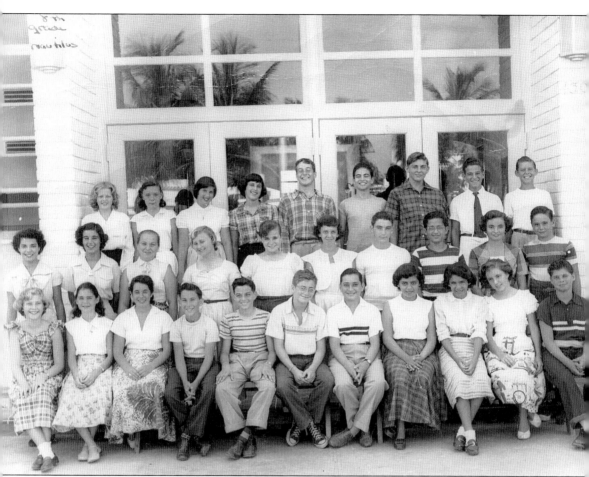

The first Nautilus Junior High School graduating class smiles happily as they prepare to leave the building at 4301 North Michigan Avenue for four years at Miami Beach High. While the names of the members of this handsome group of young people are not available, it is certain that more than one will recognize themselves in this one-of-a-kind photograph. (Courtesy Joan Kandel Worton).

Five

A New Boom and a Sad Decline

By 1950, the World War II vets were pouring into South Florida, many of them calling Miami Beach home.

There was a sign shop on the south side of Fifth Street between Collins and Washington, and innumerable happy days were spent by the youngsters of the beach roaming that neighborhood; watching the chicken throat cutters at the kosher butcher shop just south of Fifth Street on the west side of Collins Avenue; playing the pinball machines at Al's Drug Store on the southeast corner of Fifth Street and Washington; going upstairs and being fascinated with the sights and sounds and smells of the Fifth Street Gym, where great boxers such as Jake LaMotta, Willie Pep, Willie Pastrano, Kid Gavilan, and Mohammed Ali practiced for years, many of them trained by Chris Dundee and promoted by his brother, Angelo.

During the early 1950s, Miami Beach grew as the Saxony, Sans Souci, Lucerne, Allison, Lombardy, and Casablanca hotels were built, followed by the Fontainebleau designed by Morris Lapidus in 1954. The Eden Roc opened in late 1955, the Doral several years later. The Deauville was renamed the MacFadden Deauville at Sixty-seventh Street and Collins Avenue, with the Carillon following in 1958, two blocks north.

Smaller motels were opening in Surfside, and motel row (now a tasteless line of huge, out of proportion, ungainly condo monstrosities) was booming with interestingly named inns such as the Castaways, Sahara, Monaco, El Sombrero, Olympia, Pan American, and many others competing with the lower beach for business.

Great restaurants, including the Hickory House, the Park Avenue, Embers, Wolfie's, Junior's, Pumpernik's, Parham's, Piccolo's, Pickin' Chicken, Joe's, the Famous, Fan and Bill's, the Bonfire, Chary's, Place for Steak, Rascal House, the Noshery in the Saxony Hotel, Mamy's, Papy's, Angie and Fred's, Jimmy's Just a Hobby, and many others thrived.

The Jewish-style cafeterias, including the Ambassador, the Governor, Hoffman's, Dubrow's, and the Concord were completely different from today's chains, offering huge portions, wonderful breakfasts, great corned beef and pastrami sandwiches at lunch, and marvelous dinners, all served in a "hamish" (family) atmosphere very different from the impersonal tray lines of today.

Night clubs were packed, and in the winter season, lines trailed down the block waiting for a table.

It was a great place and a great time to grow up, and the area was booming, but without legalized casinos, with Las Vegas attracting more and more visitors and top-notch employees leaving to take jobs "out there," storm clouds were on the horizon. By the mid-1960s, Miami Beach was in decline, and it began a downward spiral, which only the recognition of the necessity of preserving the Art Deco District would, a long 15 years later, begin to reverse.

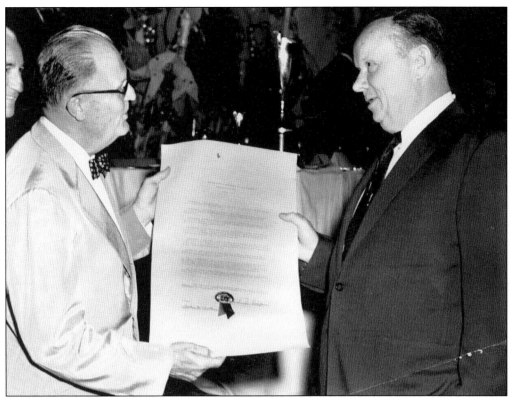

Two true Miami Beach pioneers are shown here: Pete Chase (left), Carl Fisher's right-hand man, is presented with a proclamation honoring his many years of service by longtime city manager Claude Renshaw. The two remained lifetime friends, having worked together from the time Renshaw arrived in Miami Beach in late 1925.

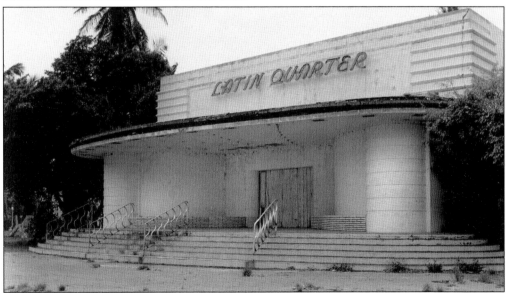

The tide was turning by the mid-1960s, and the shuttered (and now demolished) Latin Quarter reflected the downturn that Miami Beach was experiencing as shown in this 1968 photograph.

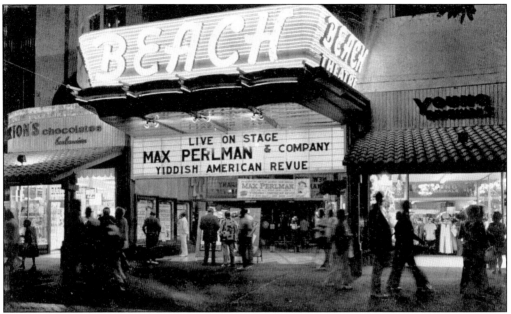

By the 1970s, even the movie theaters on Lincoln Road were becoming desperate for revenue, and the Beach Theatre, on the south side of Lincoln Road, became a Yiddish-speaking live stage production venue. It is pictured here in 1975.

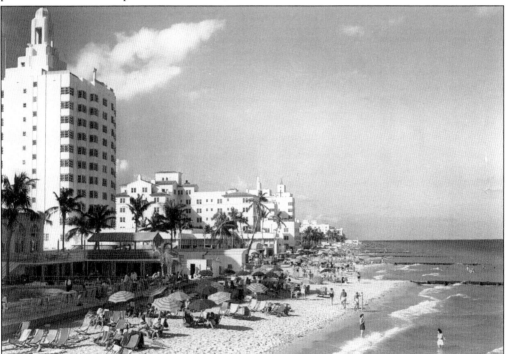

Still a beautiful setting, the beach was slowly but surely losing ground and giving way not only to newer resorts but to those that offered games of chance. The Caribbean Islands were proving to be an almost insurmountable competitor, and that destination, along with Las Vegas, was luring untold numbers of former Miami Beach guests.

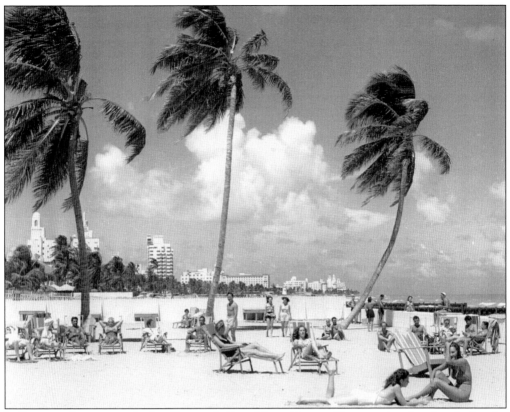

Lolling in the sun with the National, Ritz Plaza, Roney Plaza, and other hotels in the background, the tourists were still enjoying the golden sunshine and the nightlife, although the hotels' American plan, which included breakfast and dinner, would have a deleterious effect on the city's clubs and restaurants.

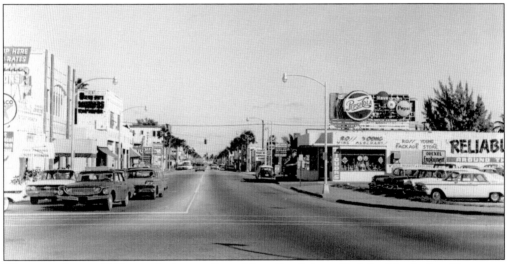

This marvelous c. 1962 view looks east from Alton Road, just off of the MacArthur Causeway. The south (right) side of the street would change completely, as in the late 1980s, the roadway was widened by several lanes and all property on that side taken for that purpose.

"Coronation" was always a big event at Miami Beach High School, as the queen and her court were chosen. This c. 1954 view was taken in the patio of the "old" Beach High just off of Espanola Way on Drexel Avenue. Regretfully, the participants cannot be named. But it is known that Bonnie Cypen, daughter of Judge Irving and Hazel Cypen, is one of the pretty little flower girls smiling happily in the front row. (Courtesy Judge Irving and Hazel Cypen.)

In May 1960, students, teachers, and staff left the old Miami Beach High and walked approximately one mile to the new Beach High at 2231 Prairie Avenue at Dade Boulevard and Washington Avenue situated on the old golf course. While it was an exciting day, taking place just a few weeks prior to the end of school so the class of 1960 could graduate from the new school, the mascot change from "Typhoons" to "Hi-Tides" and the change in colors from black and gold to scarlet and silver did not please many of the Typhoon alumni. The class of 1962 was the first class to spend any part of three years in the new school, which is now older than the "old" school was when the move was made.

The old pier at the foot of Miami Beach, with the exception of the fact that one can still fish from it, is essentially gone, but there is now a small bandshell there used for municipal events.

The lifeguard headquarters at Tenth Street and Ocean Drive are shown here, complete with the beach patrol's emergency van parked in front.

Embers was one of the beach's favorite and favored restaurants, and whether under the ownership of Sam Sterling, Radio Weiner (who later owned the Bonfire, in North Bay Village), or Walter Kaplan, the restaurant at 243 Twenty-second Street, just half a block west of Collins Avenue, was always great. The food (cooked with wood over an open pit), service, and greetings were always superb.

EMBERS RESTAURANT & COCKTAIL LOUNGE

245-22ND ST., MIAMI BEACH, FLORIDA

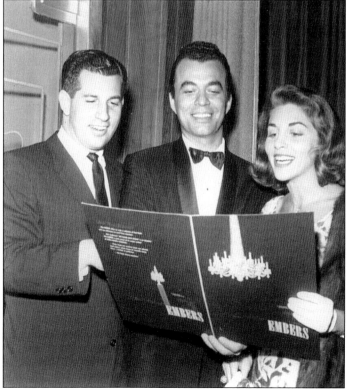

He was so well known that mail arrived at the Embers simply addressed "Mario, Miami Beach." He was the consummate maitre d' and greeter, and people poured in to the Embers, not just for the food but also for the warm personal greeting of the handsome young fellow shown in the center, holding the menu. To Mario's left is Bob Gruder, owner of the Mercury Motel; the beautiful young woman on the right is unidentified. (Courtesy Gail and Mario Talucci.)

Cocktails		
	Tomato Juice	.35
	Stone Crab	1.25
	Fresh Shrimp	1.00
	Florida Lobster	.90
	Oysters	.75
	Fresh Fruit	.60

Relishes		
	Celery and Olives	.75
	Mixed Pickles	.35
	Sweet Pickles	.35
	Dill Pickles	.35
	Celery	.40
	Queen Olives	.40
	Stuffed Celery	.75

Soups		
	Clam Chowder	.50

Fresh Seafoods (In Season)		
	Pompano, Garlic Sauce	3.00
	Pompano	2.75
	Stone Crabs	3.25
	Fried Shrimp, Tartar Sauce	2.00
	Shrimp Creole	2.00
	Fried Oysters	1.75
	Salt Water Trout	1.50
	Frog Legs	2.75
	Florida Lobster	1.75
	Spanish Mackerel	1.50
	Kingfish	1.50
	Broiled Snapper	2.00
	Scallops	2.25

Joe Weiss came to Miami Beach sometime around 1915 and cooked at Smith's Casino. In 1918, he opened his own eatery, calling it Joe's Seafood Restaurant. Many years later, the words "Stone Crabs" would be added to the restaurant's name, and the restaurant would gain fame with franchises in Japan, Las Vegas, and other places. Family-owned and -operated since the beginning, the operation was taken over by Joe's son, Jesse, and upon his retirement, his daughter JoAnne and son-in-law Irwin Sawitz managed the facility. JoAnne, now JoAnne Bass, has turned over the day-to-day management to her son, Steve, and with his Cornell Hotel School education and years of tutelage by the family, he has built a veritable dynasty. Joe's is (as the menu states) "the first established eating place on Miami Beach," although historians

Salads

Cottage Cheese and Fruit	.50
Chef's Salad	.50
Hearts of Lettuce	.40
Cole Slaw and Mayonnaise	.40
Stone Crab	3.50
Florida Lobster	1.75
Fresh Shrimp	2.00
Sliced Combination	.75
Sliced Tomatoes and Spanish Onion	.60
Sliced Cucumbers and Spanish Onion	.60
Lettuce and Tomatoes	.60
Fresh Fruit	2.00
Sliced Tomatoes	.40

Sauces and Dressings

Garlic Sauce	.25
Thousand Island	.25
Russian	.25
Roquefort	.40
Hollandaise	.50

Vegetables

Garden Spinach	.35
String Beans	.35
Green Peas	.35
Baby Lima Beans	.35
Broccoli	.50
Green Asparagus	.75
Smothered Onions	.35
French Fried Onions	.60
French Fried Eggplant	.50
Grilled Tomatoes	.60

believe it to be the oldest food and beverage operation in Miami-Dade County and possibly in the state. This menu, c. 1955, does not, unlike today's menu, feature stone crabs, but rather simply shows them (at a price of $3.25 for the order compared to about $35 today) as the third item under "Fresh Seafoods." The menu itself is a revelation and a wonderful indicator of how times have changed. In a great restaurant, everything is great, and there is no "you didn't order the right thing" nonsense. At Joe's everything is great, and the hashed brown potatoes and the cole slaw are two items that, no matter which entrée is ordered, are absolute musts as sides. Key lime pie, today's de rigueur dessert, was not even on the menu, and apple pie was 40¢. Indeed, those were the days.

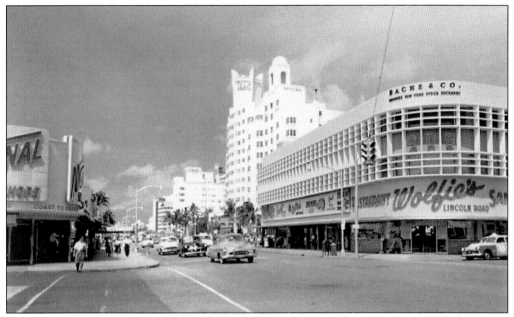

This view is of Lincoln at Collins Avenue looking north. Wolfie's Lincoln Road is directly in front on the right; National Shirt Shops is on the left; a Mercury cab, painted in the red and yellow of the Florida East Coast Railway, waits for a fare in front of Wolfie's. Those were halcyon days, but the soon-to-come burst of hotel building would not last, although the decline would begin only about 10 years after this image was made.

As the Jewish population of Miami Beach grew, so did the size of the houses of worship. Miami Beach's largest temple was Emanu-el, on the northeast corner of Seventeenth Street and Washington Avenue. It was presided over for many years by Rabbi Irving Lehrman, beloved by his congregants and a fixture in the community.

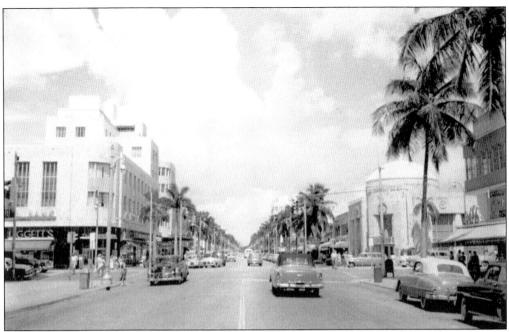

This view was taken standing about half a block east of Washington Avenue in the center of Lincoln Road, looking toward the Mercantile Bank building (site of Fisher's Lincoln Hotel) on the left and Miami Beach First Federal, a building that should have been preserved but was torn down for the monolith in the next photograph, on the right.

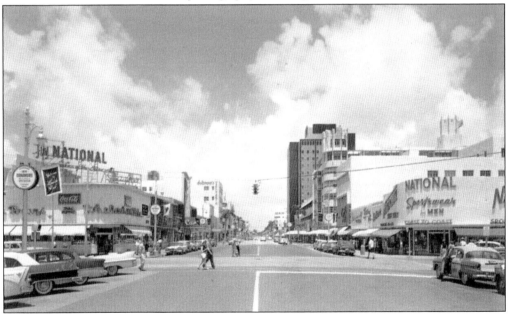

Although we are about a block and a half back (farther east) from the previous view, the big blue building on the right is what replaced the beautiful bank building that had long anchored the northwest corner of Washington and Lincoln. Here we are east of Collins, Wolfie's is to the right of the Mercury cabs, and Whelan's Drugs is on the southwest corner. The airline ticket offices are in the same building, on Collins, south of Whelan's.

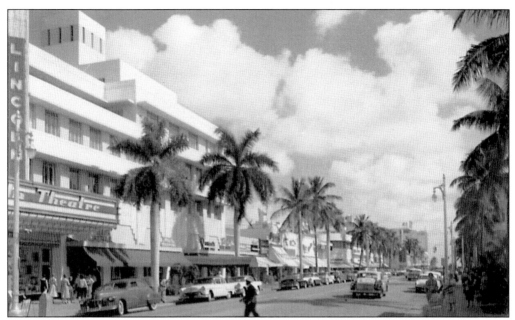

For many years, Lincoln Road was called the "Fifth Avenue of the South," with a Cadillac dealership in the building now owned by Miami Beach High School class of 1962 graduate Robert Quittner, a Bonwit Teller, a Saks store, and many other elegant and high-grade clothing and accessory stores. In the late 1950s and early 1960s, Lincoln fell on hard times, and in an act of desperation, it was decided to close the street to automobile traffic and make it a mall. The upper view was taken at the corner of Lincoln and Drexel Avenue, one block west of Washington; the Lincoln Theater is on the northeast corner. In the lower view, half a block further east, Cantinflas portraying "Pepe" is playing at the Lincoln, and the short-lived electric tram is prominent in the photograph. Lincoln Road would decline terribly, but the art deco movement and the return to life in Miami Beach has made a remarkable comeback.

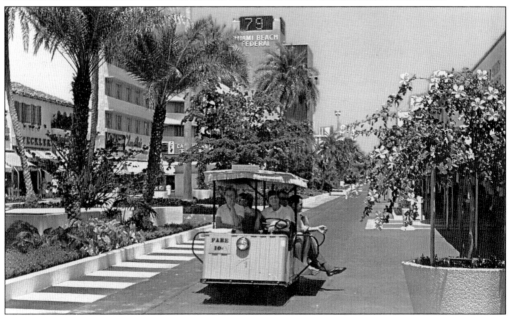

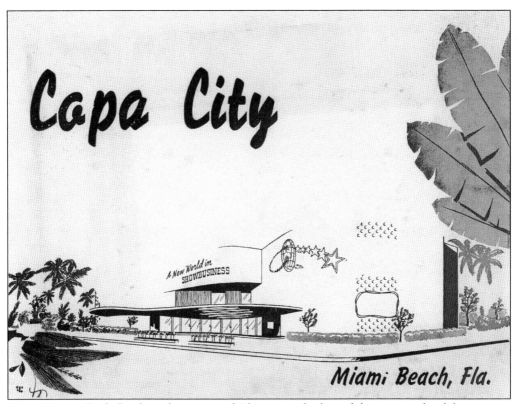

Copa City, on Dade Boulevard just west of Alton, was the last of the great night clubs to open, and unfortunately it did so too late in the 1950s to be successful. The building went through several changes, including housing a newspaper. Today it is the site of an office building. This is the jacket of the photograph that would be purchased from the photograph girl in the club.

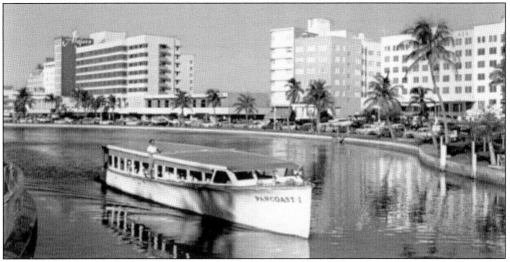

The Algiers Hotel, owned by the Levinson family of Sullivan County Catskills fame, is at left. The sightseeing boat *Pancoast I* is inbound just a few hundred feet from its dock across the street from the Roney. By the very early 1970s, the sightseeing cruises from this location were a thing of the past.

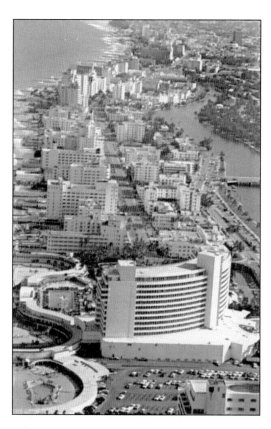

Designed by famed architect Morris Lapidus, the Fontainebleau, shown here in all its curved façade glory, would take the crown from the Roney Plaza as the premier hotel of Miami Beach. It remains so today only because, without casinos, few hoteliers are willing to make the investment necessary for construction, the city having to guarantee millions of dollars in tax breaks and other incentives in order to coax them to proceed.

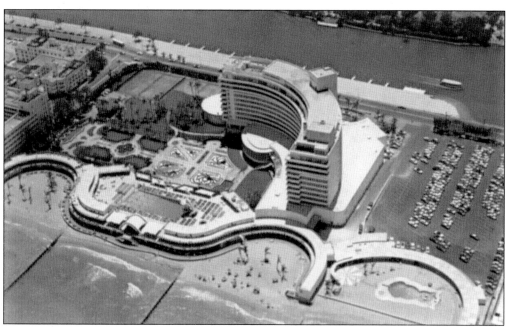

Another view of the Fontainebleau from the ocean side shows, to the north of the main pool, the "kit kat" pool, which was later roofed over when the Towers building was added.

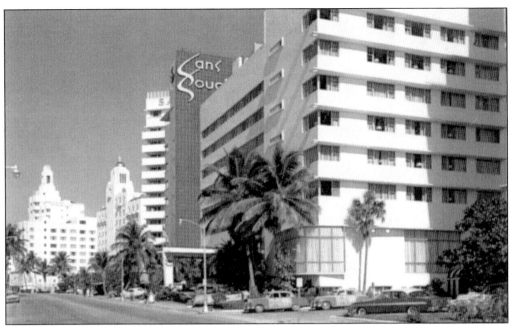

Looking north on Collins at about Thirty-third Street, the then–newly built Sans Souci is on our right, behind which, barely visible, is the Saxony.

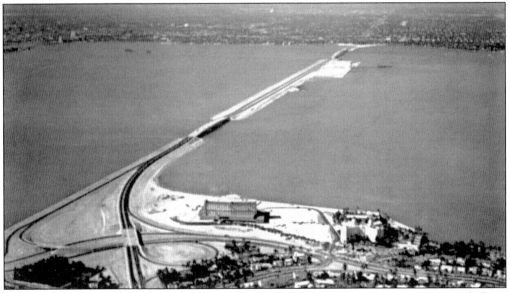

For many years, travel to Miami could only be done by using the three causeways, and if you needed to go north, you had to go via the Seventy-ninth Street Causeway. Finally after years of agitation, the state with federal aid built a causeway connecting NE Thirty-sixth Street in Miami with Forty-first Street on the beach. Named for "the Mother of Miami," Julia Tuttle, the causeway opened in 1960, cutting travel time by more than a few minutes. The new building for Mount Sinai Hospital is under construction. The two Nautilus Hotel islands, which remained intact for some years following the purchase of the building by the hospital following World War II, are gone, filled in for both causeway construction and hospital expansion. The old hotel/hospital on the right would last close to another 20 years before being demolished.

A fixture for years, "Red" Adams Sightseeing buses were owned and managed by the real "Red" Adams. Competing with the boats, the buses provided tourists with tours throughout the county and were famous for their Miami Beach nightlife packages.

After Ben Novack and his then-partner Harry Mufson split company, Mufson proceeded to build the Eden Roc resort, immediately north of the Fontainebleau property. In a gesture of uncommon spite, Novack built the Fontainebleau Towers, increasing that hotel's room count from 565 to over 1,000, but he left the north wall of the towers building blank and unpainted with all rooms facing south. Although the gesture effectively blocked the winter sun from the Eden Roc's pool deck, Mufson was able to build an extension of the deck, with a new pool, thereby giving his guests the sun they came to Florida for. Both men are now deceased, and the blank wall is still blank, but it is at least painted white.

When the Casablanca Hotel opened at Sixty-forth Street and Collins Avenue in 1952, it was "the talk of the town," for everybody was amazed and astounded by "the four guys holding up the porte cochere." The close-up of the brochure features the statuary, while the photograph of the hotel gives the perspective. Before Las Vegas, the hotel was the talk of the nation.

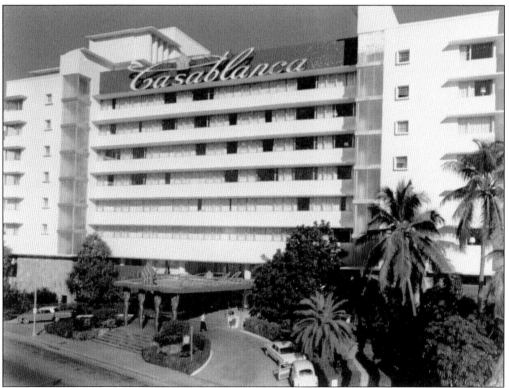

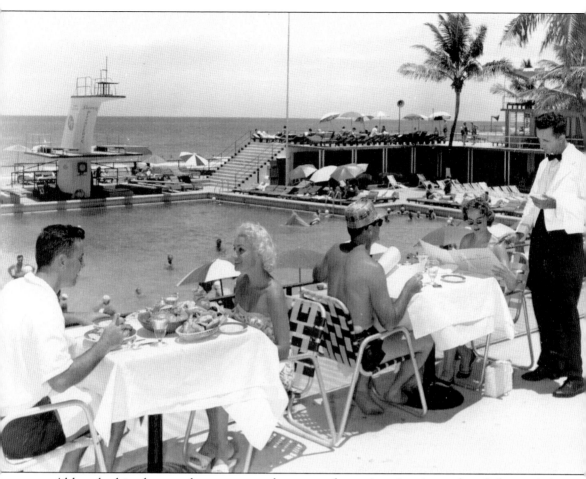

Although this photograph appears on the cover, the entire view is worthy of the reader's attention. This is the outdoor dining deck of the Sherry Frontenac Hotel at Sixty-sixth Street and Collins Avenue. One couple is enjoying their salads, while the other couple is having their order taken. The Sherry was, like so many other beach hotels, the talk of the town when it was built because it had twin towers, approximately 10 stories each, with an enclosed walkway connecting the top floors. Only the Fontainebleau's and MacFadden Deauville's diving boards were higher than the Sherry's.

From the east end of the pool of the Sherry Frontenac, the hotel's twin towers and the walkway noted on page 110 are visible.

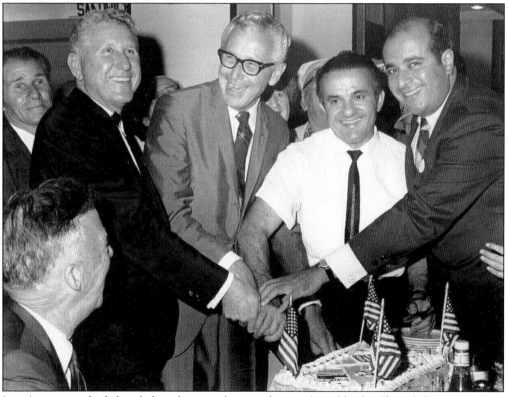

It isn't certain which hotel this photograph was taken in (possibly the Sherry), but it is a great and rare image. Cutting the United Auto Worker's cake at their Miami Beach convention c. 1962 are, from left to right, Judge Irving Cypen, Florida governor Leroy Collins, Dave Taub, and Miami Beach mayor Jay Dermer. (Courtesy Hazel and Judge Irving Cypen.)

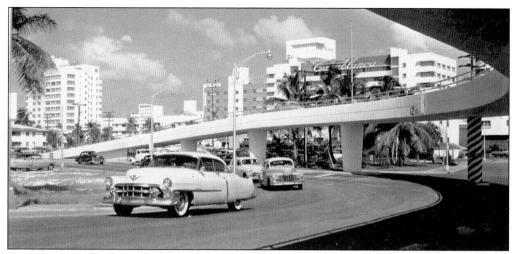

To improve traffic flow, and along with the Sixty-third Street Bridge, Miami Beach built an overpass for eastbound traffic turning north onto Indian Creek Drive. The only problem was that the overpass was incredibly narrow, and it was built too low for large trucks going southbound on Indian Creek to get under. In any event, it did help somewhat, and now with its removal imminent, a look at the then–newly built (c. 1952–1953) structure with the relatively new hotels behind it and the 1950s Cadillac heading west on Sixty-third Street just about to cross the bridge appears quite timely.

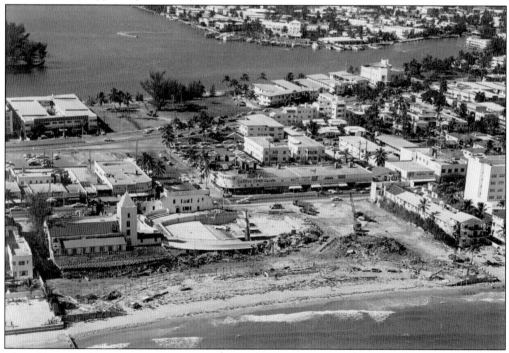

The old MacFadden Deauville is days away from complete annihilation, and construction will start thereafter on a new Deauville. A favorite for Beach High class reunions, the 1957-built property will hopefully not go the way of so many hotels, either torn down or converted to condos. Pumpernik's, the great deli restaurant directly across Collins Avenue, owned by the Linksman and Bookbinder families, is long gone, replaced by a chain drug store.

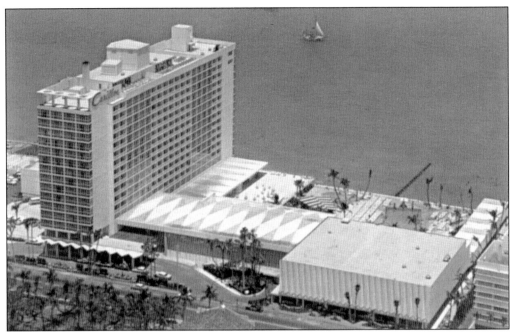

The Carillon, between Sixty-eighth and Sixty-ninth Streets, opened in late 1957 just in time for one of the worst winters the beach had ever seen. It was not good for business. The hotel survived for about 35 years despite an attempt to convert it to condos. When that did not work out, it was essentially abandoned and has now been torn down.

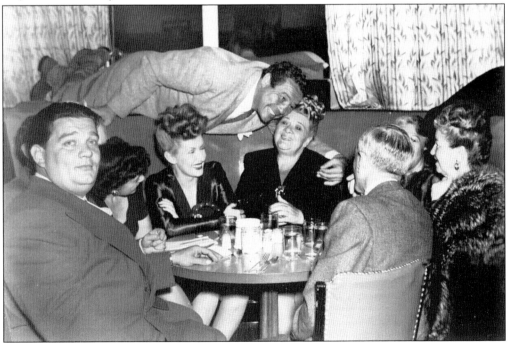

With Billy Vine the great prizefighter, at far left looking at the camera, Max Baer leans over to hug the immortal Sophie Tucker (center), c. 1956. This shot was likely taken at the Chez Paree nightclub.

One of the most popular mayors in both Miami Beach and Dade County history was the incredibly charming and always politically astute Chuck Hall. His travel agency, on Arthur Godfrey Road, did a booming business, and Chuck was never one to miss a photograph opportunity. Here he is "chucking the chin" of the adorable "Little Miss Heart Fund," Mindy Sterling, daughter of Dick and Bookie Sterling. Mindy's other dad, who married her mother following her divorce from Dick when Mindy was still very young, is Dave Rogers, a Beach High graduate and much-loved local. Mindy went to California, appearing in numerous sitcoms and movies, but she is best known for her incredible role as the evil (but show-stealing) "Frau Farbissina," female foil to Mike Myers, star of the *Austin Powers* movies, who is now a good friend of Ms. Sterling's.

114

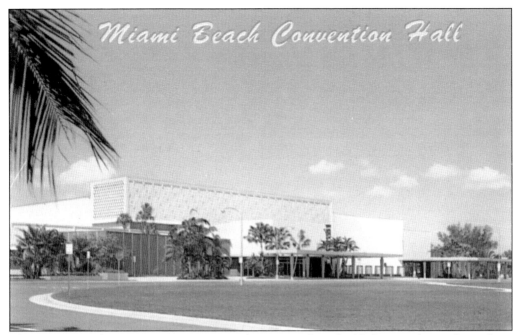

The Miami Beach Convention Center was later more than doubled in size but is shown here shortly after opening in the early 1960s. At the time, it was the largest convention center in the South.

How the Governor was loved. Located on Washington between the Cinema Theater and Kress's, the food was great, the smells were wonderful, and the atmosphere was always memorable. Along with the Ambassador, Hoffman's, Dubrow's, and the Concord, the Governor has been gone for more than 30 years, yet the mention of its name evokes strong memories from anyone who ever enjoyed a meal there.

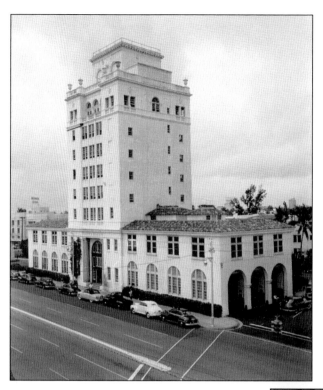

Although this view of city hall was made in the late 1940s or very early 1950s, the building has been preserved, and when the new city hall opened on Seventeenth Street, in 1974 or 1975, Claude Renshaw prevailed upon the city administration to allow the author to clean out the building. An enormous amount of historical material, which would have otherwise been junked (including this photograph), was saved for posterity.

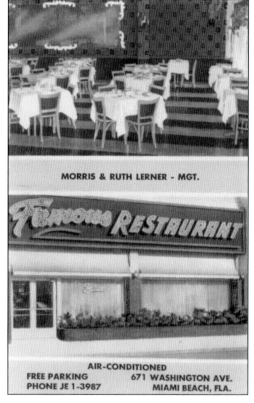

MORRIS & RUTH LERNER - MGT.

Famous RESTAURANT

AIR-CONDITIONED
FREE PARKING 671 WASHINGTON AVE.
PHONE JE 1-3987 MIAMI BEACH, FLA.

The Lerner family and later the Zuckermans operated one of Miami Beach's most beloved restaurants, the Famous. Famous it was as much for the Hungarian Mixed Grill as for the seltzer bottle and chocolate syrup on the table. When it closed in the early 1970s, Miami Beach lost a never-to-be-replaced institution.

For many years following World War II, the city's Parks and Recreation Department, under the direction of Jack Woody, ran year-round athletic programs for the beach's children beginning with the preschoolers and going through teenagers. The various parks would compete against each other in sports ranging from soccer and rag football to basketball and baseball, culminating each year in the city-wide championships. The mid-beach kids had Polo Park (shown above), the South Beach kids had South Shore and Flamingo Parks, and the north-enders had Crespi, North Shore (shown below), and Normandy Parks. Most had athletic fields and tennis and basketball courts and were staffed six days a week by recreation leaders, most of them high school and college students, with adult supervision in the major facilities, including Flamingo, North Shore, Normandy, and Polo. Those were heady days for so many, and for years, the Beach High swimmers practiced at the Flamingo Park pool, while the gridders and diamond men used the fields at Flamingo until the move to the new school. The school provided ample space for practice for all sports except swimming, track, and tennis, which continued to use the Flamingo Park facilities, compliments of the City.

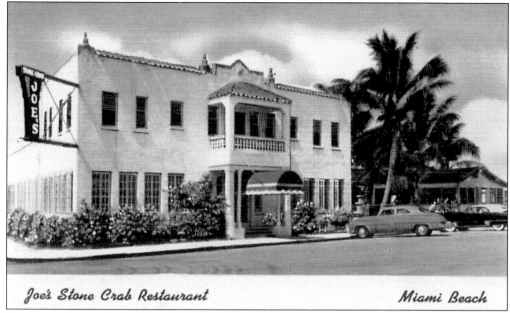

Joe's Stone Crab Restaurant *Miami Beach*

Now more than tripled in size with the original store visible on the right, Joe's has occupied this building fronting on Biscayne Street for more than 50 years. This building has been incorporated into the larger facility. For a look at Joe's menu, *c.* 1953, see pages 100 and 101.

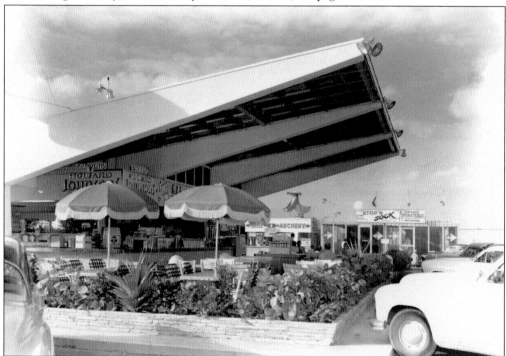

Opening in 1954 on the Colonel Jim's Drive-In property, Fun Fair was an instant hit, with its game room; miniature golf; and the best hot dogs (well, maybe not as great as Lum's steamed in beer), hamburgers (much better than Ollie's), and pizza burgers in town. The open-air restaurant was a great gathering place for kids of all ages until it closed in the mid-1970s.

Originally occupied by a restaurant called the Epicure (not related to the gourmet market downtown), Curry's was a fixture with its marvelous corn sticks, Tahitian-motif wall paintings, and reasonable prices for years and years. But with the neighborhood and the clientele changing, and a serious dearth of tourists, the restaurant finally closed in 1998.

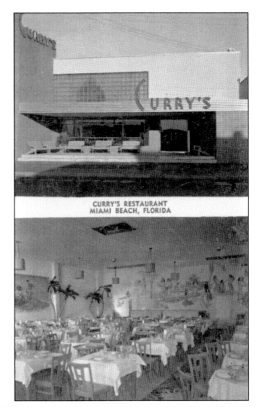

CURRY'S RESTAURANT
MIAMI BEACH, FLORIDA

Roberto was the consummate showman, and he sang, danced, mixed, told stories, and entertained behind the bar at the Edward Hotel on Tenth and Collins Avenue for years. Although earlier than the time frame of this chapter, he is included here because there was nobody that even came close to his level of showmanship until the appearance of Stanley the Great at the Castaways in the early 1960s.

He was the reincarnation of the great Roberto, and with new drinks, new environment, new customers, and new ideas, Stanley the Great held sway at the Tahitian Bar of the Castaways, at 163rd Street and Collins Avenue, for almost 20 years. The motel closed and has been replaced with absolutely undistinguished high-rises, but Stanley's legacy lives on in both in his guests' memories and in the postcards and photographs of him. On New Year's Eve 2004, Stanley was the celebrity bartender at the home of Al Diaz and Cindy Seipp in Coral Gables and was as great a showman as ever, this close to 15 years after the Castaways was shuttered for good. Sadly, Stanley passed away in the early part of 2005.

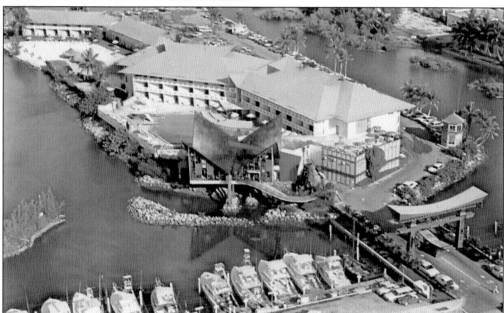

The Castaways was on both sides of Collins Avenue, with the Tahitian Bar on the east side and the Wreck Bar in this building on the west side. At this great and exciting place, the "Wreckettes" were the bar's personable and charming cocktail waitresses, and they, along with the late Johnny Pachivas, the bar's assistant manager and an eighth-degree karate black belt (there were very few problems at the Wreck Bar), ensured great times and fun evenings for all.

Six

ART DECO COMES BACK TO LIFE, AND MIAMI BEACH CHANGES

By the end of the 1960s, it appeared as if Miami Beach, as a resort, was as good as out of business. Much of Lincoln Road was shuttered, numerous hotels had closed or were being converted to rental space, and the high-rises on Collins Avenue north of the Doral on both sides of the street had effectively created a concrete canyon.

Miami Beach, simply put, was giving off the aura of a city that had reached the end of its life as a destination. Longtime visitors had aged and had either purchased condos or were, along with their children and grandchildren, going to new and more glamorous vacation spots. Going into the 1970s, change for the worse had become, it appeared, a fatal and final denouement.

As far as most people—residents, visitors, and hospitality industry employees and owners— were concerned, Miami Beach was kaput, but with the arrival of Barbara Capitman and her son, Andrew, re-birth, unknown to anybody at the time, was just around the corner.

The Capitmans were the first to see the beauty and uniqueness of the art deco style of architecture, and Mrs. Capitman determined that it was to be her role in life to not only save as much of what would become the Art Deco District as possible, but to bring Miami Beach back to life as a destination resort. Through her insightful and forward-looking thinking, almost all that she prophesied, worked for, and dedicated her life to has come to pass. Through and because of the Capitmans and others with the same dedication and devotion to the future of the city, Miami Beach was once again about to be reborn.

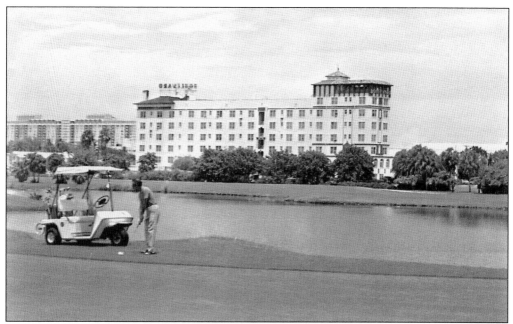

This view is on the Bayshore Golf Course looking south toward the Boulevard Hotel with high-rises looming in the background. Though the Boulevard would soon be gone from the scene and apartments would be built in its place, the golf links have been upgraded, and a new Bayshore clubhouse has recently been built.

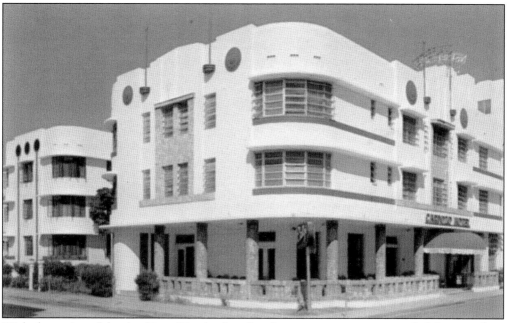

With the saving of the Art Deco District, hoteliers began to concentrate on rehabilitating their long-neglected properties. The Cardozo at Thirteenth Street and Ocean Drive has long been a favorite of deco aficionados.

Typical of the devastation wrought upon the beach, as magnificent mansions were torn down, is the Carriage House at Fifty-Fourth Street and Collins Avenue. For five years, it was the home of Bernard's Restaurant, but the building is now just another of the endless line of high-rises blocking the ocean view and is a perfect example of what never should have been built on the east side of Collins Avenue.

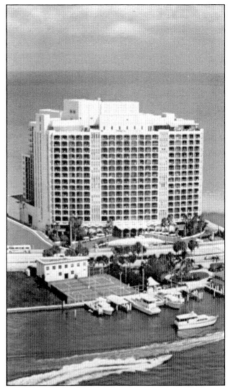

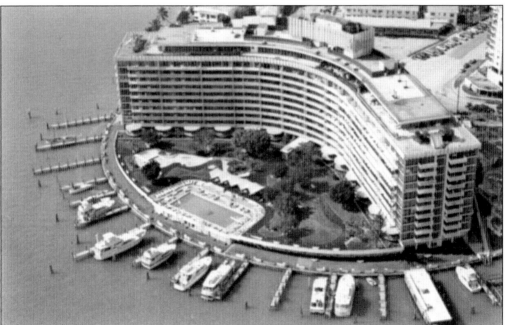

The new King Cole was built at the south end of Bay Drive on Normandy Isle, replacing a low-rise but elderly facility that had been built there when Miami Heart Institute bought the original hotel by that name on Forty-Seventh Street. Massively overshadowing its neighbors, the building is currently undergoing major refurbishment.

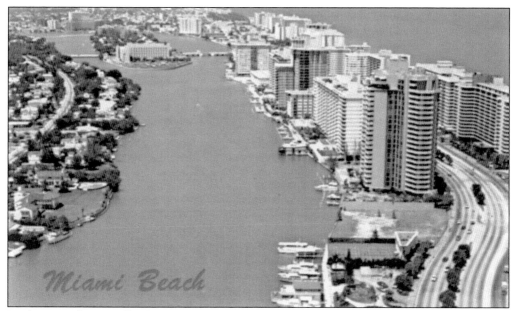

Looking north on Collins Avenue toward St. Francis Hospital (no longer extant, replaced by even more condos and apartments), it is evident that the concrete canyon of Collins Avenue has made this drive nothing more than a southern extension of New York City.

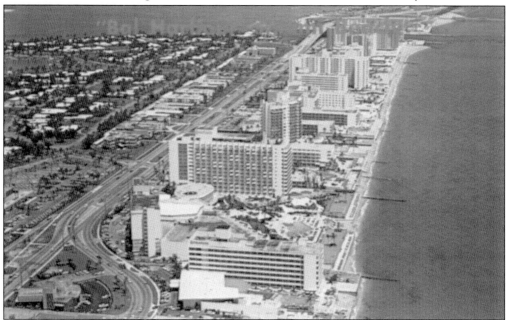

This view looks north from Ninety-sixth Street and Collins Avenue. Shown here from bottom to top are the Singapore (replaced by condos), the Americana (now the Sheraton Bal Harbour and slated for demolition and replacement by high-rise condos), the Balmoral (now replaced by a condo of the same name), and the Sea View (possibly the only hotel remaining in Bal Harbour). The remainder of the strip to the Haulover Bridge consists of more condos and apartments and is as undistinguished as those areas of Miami Beach where monstrous buildings have been allowed to sprout.

Taking up the art deco spirit and with all credit due to its ownership, the Plymouth Hotel, at Park Avenue and Twenty-first Street, is a perfect example of what can be done when the spirit of the Art Deco District is followed.

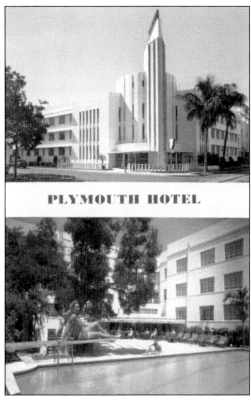

PLYMOUTH HOTEL

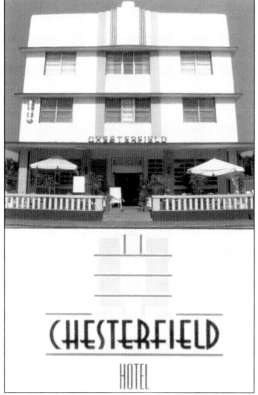

The Chesterfield at 855 Collins Avenue is another sparkling example of deco district restoration.

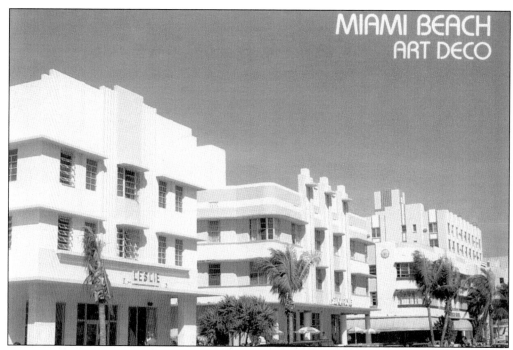

Ocean Drive, mobbed almost 24 hours a day, is a mecca for tourists and sightseers as they enjoy both the day and night life that has returned to an area that was almost forgotten before the arrival of the Capitmans and the approval of the district.

With the success of the district, Miami's Channel Seven introduced a popular nightly program called *Deco Drive*, which has been a staple of the station for close to 10 years now. It features South Beach fashions, partygoers, new restaurants and bars, and all of the exciting happenings that continue to lift the spirits of guests, customers, managers, and owners of the various businesses in what is now called "SoBe."

Jackie Gleason was and will always remain in the collective mind as "The Great One." It is absolutely indisputable that he was crucial to bringing national attention back to Miami Beach when he moved his popular television show to Miami Beach Auditorium. Garnering the highest ratings on television at the time, the show began with a boat zooming west on the Atlantic toward the Miami Beach hotels in the background and announcer Jack Lescoulie intoning, in that marvelous voice of his, "From Miami Beach, the sun and fun capital of the world, it's the *Jackie Gleason Show*. Starring . . . " Gleason, June Taylor, and others from the show became fixtures in the area, and Gleason would soon permanently move to South Florida. He always loved Miami Beach and was able to indulge his favorite pastime, as he is doing here, at either LaGorce Country Club, Bayshore, or Normandy Shores, Miami Beach's "north end" golf club, on a several-times-a-week basis.

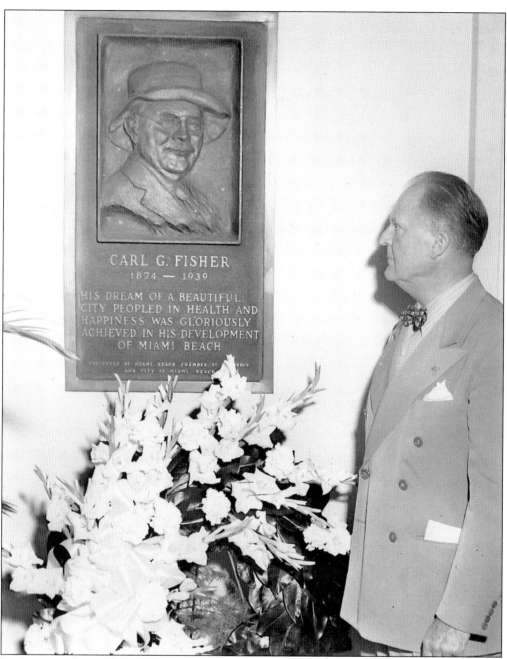

In closing, we honor the memory of two of Miami Beach's most important historical figures as the late Pete Chase admires the plaque dedicated by the city and the chamber of commerce, which he founded, to the memory of the true and real and only "Mr. Miami Beach," Carl Graham Fisher.